752 95 485
M
Martin
 Color: how to see it, how
to paint it

DATE DUE			

COLOR

How to see it
How to paint it

COLOR

How to see it
How to paint it

CHARTWELL
BOOKS, INC.

Judy Martin

Published by Chartwell Books
A Division of Book Sales, Inc.
110 Enterprise Avenue
Secaucus, New Jersey 07094

This edition produced for sale in the U.S.A. its territories
and dependencies only.

ISBN 0-7858-0053-0

This book was designed and produced by
Quarto Publishing plc
The Old Brewery
6 Blundell Street
London N7 9BH

Senior Editor: Hazel Harrison
Senior Art Director: Mark Stevens
Designer: Nick Clark
Picture Researcher: Laura Bangert
Photographers: Martin Norris, Chas Wilder, Jon Wyand
Art Director: Moira Clinch
Editorial Director: Sophie Collins
Picture Research Manager: Rebecca Horsewood

The author would like to thank all the artists who have
contributed to the book, and particularly the artist-
demonstrators. Special thanks to Hazel Harrison for her
valuable support on this and previous projects; and to Jon
Lloyd at Daler-Rowney for interesting information on
paint materials and manufacture.

> **"** When you go out to paint, try to forget what object you have before you — a tree, a house, a field, or whatever. Merely think, here is a little square of blue, here an oblong of pink, here a streak of yellow, and paint it just as it looks to you, the exact colour and shape … **"**

Claude Monet, 1889

contents

1

Color materials

A survey of the main color media and the color ranges of artists' paints and pastels, with advice on color mixing on the palette, painting techniques and surface effects.

3

Using color

Color interactions

A summary of the basic principles of color theory, related to practical application of paint and pastel colors and effective ways of planning color composition.

Discussion of how to analyse and interpret colors in a wide range of subject matter, illustrated with selected gallery images and step-by-step demonstrations in all the featured media.

Color materials

When you produce a painting, a number of different influences affect your interpretation of the subject, but perhaps the most important are the paint texture and colour range of the medium that you use. These create the character of the picture, so that the viewer, who has probably never seen the original inspiration, judges the painting on its own terms.

Whether your intention is to match colours, tones and textures exactly or to re-create a broad impression of your visual sensations, the properties of the medium will govern what you are able to do. This need not be a restriction, since all media enable you to combine different techniques and achieve a variety of surface effects. But each one has specific characteristics which may modify your approach. There is no point in trying to make one medium imitate another, or to use it in ways that are obviously unsympathetic – this would introduce unnecessary practical problems.

MEDIA

To use colour confidently you need to feel comfortable in handling your materials and applying particular techniques, so this is where our investigation of colour begins. Later chapters explore the more abstract principles of colour relationships, and look at how both material and purely visual elements can be successfully combined to create descriptive or expressive qualities in a painting.

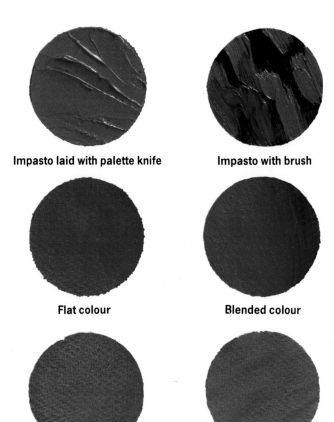

Impasto laid with palette knife

Impasto with brush

Flat colour

Blended colour

Glaze (paint thinned with turpentine and oil)

Blended glazes

The samples above show the characteristic texture of oil paint applied to a surface in six different ways.

T his book concentrates on the most versatile and direct of colour media: paints and soft pastels. The basic constituent of both paints and pastels is pigment, the colouring agent; the difference in use and effect comes mainly from the medium, or vehicle, that contains the pigments and gives the colours a particular texture and handling properties.

Oil paint The fluid medium is oil, usually linseed. Used straight from the tube, oil paint has a smooth, buttery consistency, but the paint can be thinned with addi-

END WALL
Timothy Easton • Oil
The dense, movable oil medium lends itself to subtle blending and complex textural effects. This artist creates a range of beautifully muted colours to describe the weathering of wood, metal, brick and stone, but also renders the dramatic tonal contrasts of interior and exterior shapes.

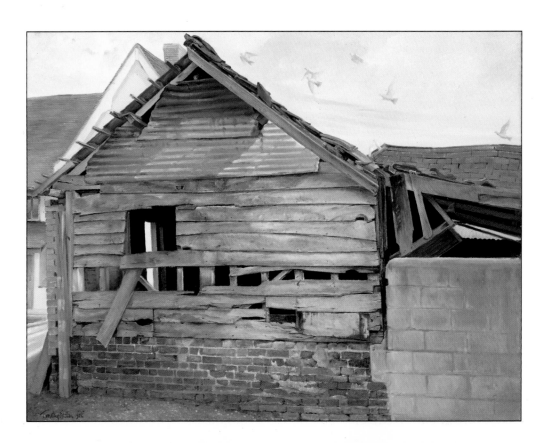

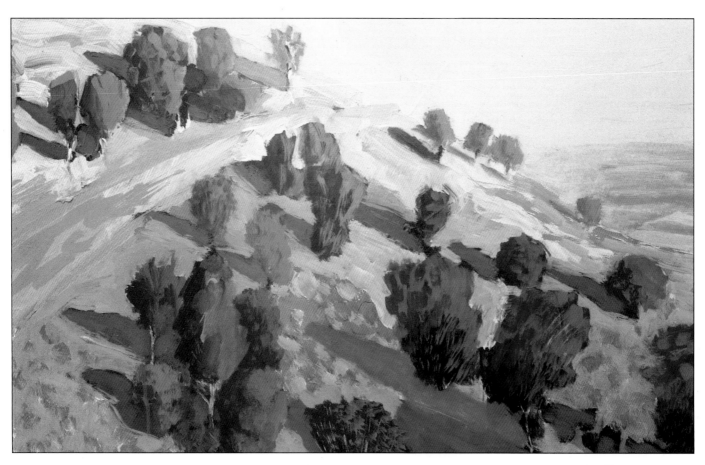

NORTH HILL MALVERN
Paul Powis ● Acrylic
Vibrant hues, brilliant, pale lights and heavily textured brush-strokes are all characteristic features of acrylic painting, although the medium can also be used to develop solid, flat colour areas and hard-edged shapes. Quick-drying acrylics can be built up in successive layers to produce a highly active surface, as in this painting, where dragged and stippled textures are played off against patches of solid, opaque colour.

Impasto with palette knife

Impasto with brush

Flat colour

Blended colour

Glaze (paint thinned with water and glaze medium)

Overlaid glazes

tional oil or turpentine. Oil paint is slow-drying, but the colours dry true. It is a rich, lush and very versatile medium – thickly applied it is dense and opaque, but it becomes increasingly translucent when thinned. But the fact that the paint remains moist on the working surface for an extended period can make it difficult to handle colours cleanly and boldly.

Acrylic paint In acrylics, the pigments are suspended in a synthetic resin. The paint is viscous and glossy, can be thinned as required with water or various special mediums, and dries very rapidly without colour loss. Once dry it is completely cohesive and water-resistant.

Because it is so quick-drying it can be less easy to blend or brush out evenly than oil, but the same pro-

The samples above show the characteristic texture of acrylic applied to a surface in six different ways.

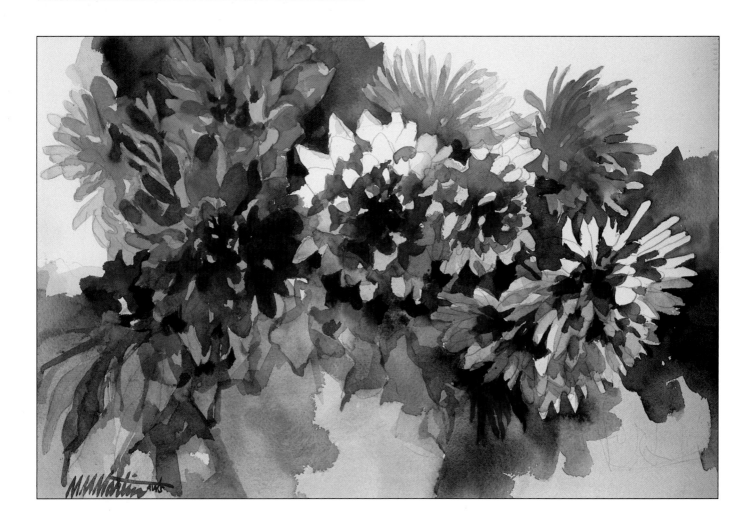

DAHLIA STARS
Margaret M Martin •
Watercolour
This bold flower painting demonstrates all the best features of watercolour: the intensity of full-strength colours, the delicacy of diluted washes and the intricate layering of internal shapes and forms. The artist has made particularly effective use of the unpainted areas of white paper to light up the composition and emphasize the free brushwork describing the ragged-petalled flowers.

**Full strength wash
(watercolour)**

Blended colours

Graded wash

Flat colour (gouache)

These samples show watercolour and gouache paints applied in different strengths to achieve various effects. The two circles above show a full-strength watercolour wash and flat colour gouache surface showing their translucence and opacity respectively.

Variegated wash (wet into wet)

Broken colour

Brush drawing over dry wash

Washes wet over dry

perty makes it excellent both for continuous over-painting without any bleed-through or pick-up from underlayers, and for thin, translucent glazing. The dried paint has a plasticized texture and often a noticeable sheen, but matt effects can be achieved using specially formulated mediums added to the paint. You can also obtain very thick, dense impasto textures by adding paste or gel, which bulks out the paint.

Watercolour A gum binder is mixed with the pigments, giving the paint a flowing, transparent texture. Water-colours are available in tubes and semi-moist pans. Many artists prefer the former, as they can be used at full strength or diluted with water to form colour washes, while the paint in pans has to be loosened by brushing out with water.

Colours lighten as they dry – a heavily diluted wash may become extremely faint – and remain water-soluble. Dark shades are built up in successive applications of colour. The purity and brilliance of watercolours is the main reason for their popularity. Traditionally, colours are never mixed with white, and highlights are achieved by leaving the white paper bare or thinly covered. The white of the paper also gives an underlying luminosity.

Gouache This is a form of opaque watercolour. Pigments are similarly held in a gum binder, but the lighter colours contain white to increase their opacity.

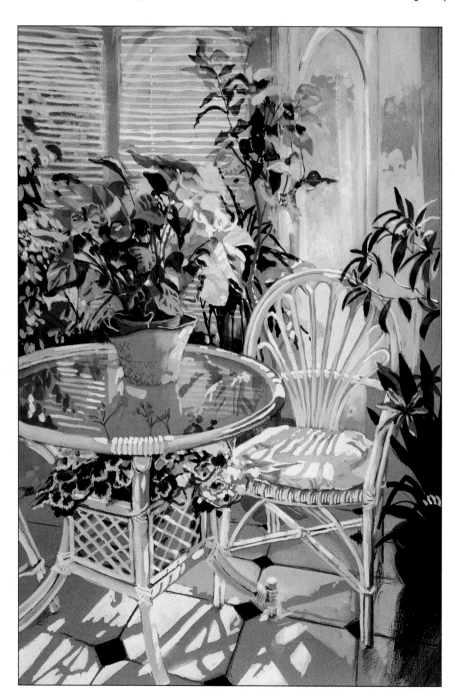

ROSIE'S ROOM
Hazel Soan • Gouache
The thickness and opacity of gouache enabled the artist to combine strong graphic and painterly qualities. The pale tones and clean whites stand out sharply against the vibrant greens and heavy, dark tones, creating the quality of light. The surface patterns and textures, however, are rich and varied, integrating the different colour elements while preserving the essential contrasts.

Gouache brushes out evenly, and if used with little water dries to a very flat, clean finish. Extensive over-painting can create problems, however, as the paint remains water-soluble, and a new layer may pick up the colours underneath. The surface also appears to have a slight bloom, because the white content leaves a fine chalky residue. This can add to the brightness of pure hues and pale tints, but may devalue the richness of dark tones.

Soft pastel These colour sticks are almost pure pigment; the pigment particles may be mixed with clay or a light gum binder, but only just enough to enable them to be compressed into solid form. Pastel is applied to a "toothed" surface, such as paper with a pronounced grain, the surface of which grips the loose colour. Pastel colours are typically very vibrant, often appearing lighter on the paper than in the stick form; there are very few colours that provide really dark tones. Pastels are conventionally applied dry to a dry surface – usually a tinted paper – but can be combined with watercolour, gouache or acrylic paint in mixed-media techniques.

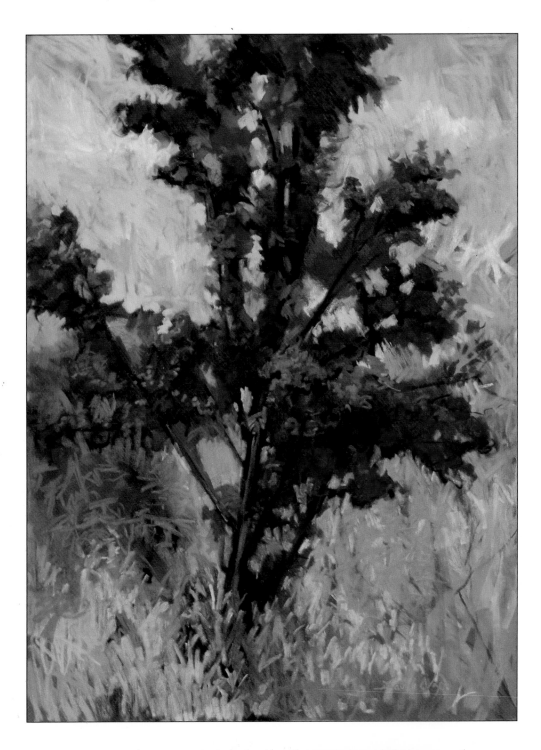

THE MAYFLOWER TREE
David Napp • Pastel
The fact that pastel colours cannot be pre-mixed may initially seem a disadvantage, but since this requires the artist to make deliberate and sometimes rapid decisions it can give a very dynamic character to the work. As you learn to control the loose texture of soft pastel, there is also plenty of scope for adjusting the colour interactions. In this painting, small strokes acting all over the surface produce blended effects in the background colour masses, but also bring out the tree with vivid colour accents and emphatic contrasts.

Strokes with pastel tip

Heavy shading

Blended colours, tip strokes

The samples left show the characteristic texture of pastels applied to a surface in six different ways.

Strokes with side of pastel

Broken colour

Blended colours, side strokes

PIGMENTS

A pigment is a solid, coloured material ground into tiny particles. It is dispersed into the liquid medium of the paint but does not dissolve. Oil or watercolour paints sometimes separate out in the tube, and when this occurs you can see that the medium is not colour-stained by the pigment.

Some pigments, for example earth colours (ochres and siennas) that derive from fine earths and clays, are natural solids. Others are actually vegetable or synthetic dyes that have to be given solid form, for example the "lake" pigments are dyes fixed on an inert pigment that does not contribute colour of its own or chemically alter the dye colour. Many colours derived originally from mineral and metallic sources: cadmium, cobalt and chrome colours from forms of cadmium, cobalt and chromium, and the "Mars" colours from iron oxides. Modern chemically developed synthetic pigments such as the phthalocyanine colours have greatly increased the range and brilliance of the artist's palette.

In preparation of artist's materials, finely ground pigments are mixed with the fluid medium and the paint is then milled – flowed between heavy rollers – to take the pigment particles down to minimum size for optimum colour value. In high quality paints, the liquid medium (including ingredients such as wetting agent and preservative added to improve handling and storage qualities) does not materially affect the colour of the pigment. In inexpensive paint ranges, an inert filler, or extender, may be added to bulk out the quantity of paint; this can somewhat devalue the paint colours, especially in mixing, so it is important to work with the good-quality materials which will retain their colour value.

Some manufacturers produce two ranges of watercolour and oil paints, one distinguished by being branded "artist's" quality, which is the finest. But all materials supplied by reputable manufacturers are produced to the highest possible standards of performance and permanence for their range and price bracket. The cost of pigments varies and in high-quality paint and pastel ranges this translates into banded price categories for different colours.

Although we think of oil paint as an opaque medium and watercolour as transparent, the pigments themselves also have inherent qualities of opacity or transparency, which can affect the way paint handles and appears on the working surface. Transparency is not related to lightness – some of the rich, mid-toned and deep colours come from transparent pigments, including alizarin crimson, viridian and ultramarine. This can affect the covering power of the paint when you brush it out. A single paint layer may retain luminosity from a white ground beneath, and one layer of overpainting may not completely cover an underlayer. But trans-

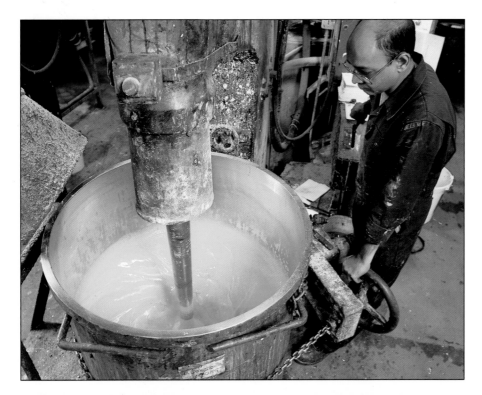

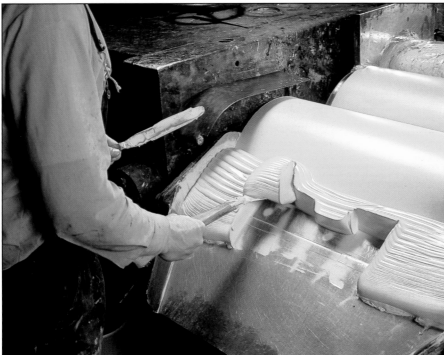

These pictures show the two main stages in manufacturing a batch of oil paint. All the ingredients are measured in large but precise quantities and thoroughly mixed in a vat (top left). The paint is milled between rollers (below left) to perfect colour and consistency.

parent pigments help to maintain the clarity of colour mixes.

Black and white pigments, brown-reds and burnt umber are naturally opaque, and this quality can dull paint mixtures where the opaque colours are used for shading. In gouache and soft pastel, the character of the pigment has less practical significance than in oil, acrylic or watercolour paint, as both media are manufactured to appear fully opaque on the working surface.

PERMANENCE

Some pigments are naturally durable and lightfast, others naturally "fugitive" – they will literally fade out of a painting over time and exposure to ordinary light. Despite many modern improvements in the chemical composition of pigments and rigorous testing of durability, there is still a small number of paint colours whose permanence cannot be guaranteed, particularly

in the red/purple range. Manufacturers normally include a permanence coding that enables you to check how reliable each colour should be – most are acceptably lightfast under normal exposure to both natural and artificial light. While it is clearly advisable to avoid using fugitive colours in work that is intended to last, it is not worth allowing anxieties about permanence to inhibit unnecessarily your choice of colours for painting and your enjoyment of using them.

Media primarily intended for use in preparing artwork for reproduction may be less permanent. Ranges called "designer's" gouache and certain kinds of coloured inks and liquid watercolours fall into this category, and may contain a higher proportion of unreliable colours. Check the manufacturer's advice and permanence ratings on these products very carefully if you want to use them in paintings intended for long-term display.

PAINT COLORS

The names of tube colours provide a means of identification and comparison between different brands and media. Although there may be slight variations, you can expect vermilion to be a certain kind of bright orange-red, viridian to be a deep, translucent green, and so on. But although traditional pigment names are still used, this does not necessarily indicate the continuing use of the original pigments. Ultramarine, for example, originally derived from the precious stone lapis lazuli, an expensive and scarce resource; modern ultramarine pigments, like many others, are artificially manufactured.

Certain pigments cannot be used for certain types of paint, so there are some colours that are equivalent to one another. For example, it was found that the normal source of Prussian blue used for oil and watercolour paints did not mix with acrylic bases, so it was replaced in acrylics by phthalocyanine (also called monestial or monastral blue), which is similar in many respects. Some tube colours have descriptive names, such as leaf green or ruby red, rather than a pigment name. Such colours may, in fact, contain a mixture of pigments.

When you buy paints, whether you are beginning work with a manufacturer's starter pack, building up your own palette of colours or adding to existing stock, it can be difficult to tell exactly what you are getting. Because of the limitations of colour printing and the difference between painted and printed colours, the colour bands on the tubes and on manufacturers' colour charts are only an approximation; you may find the colours look very different when applied to canvas or paper. Further, you cannot tell from looking at a tiny square of colour how the paint dilutes or brushes out on paper or canvas. Pastels present less of a problem, as they are usually displayed in open trays as well as sold in sealed presentation boxes, but even so the stick colour can change considerably when applied to paper.

The following pages provide colour swatches which allow you to familiarize yourself with the visual qualities of specific paint and pastel colours. They are grouped in "families" – reds, yellows, blues, etc, and the selected samples are based on the most widely used and versatile colours. As far as possible, they have been chosen to enable direct comparisons between media. The colours' behaviour in mixing is explored on pages 34–43, so you may wish to refer to that section also before buying new or additional colours.

These are representative types of the five main colour media demonstrated in the projects and examples throughout this book: **1** oil, **2** gouache, **3** watercolour in tube and pan form, **4** pastel, **5** acrylic. To obtain the best colour effects and permanence, it is advisable to use the highest quality artists' ranges in all media.

REDS

This most powerful colour in the spectrum is represented in artist's paints by a wide range of hues. The most generous selection occurs in oils and watercolours; acrylic, gouache and pastel are more limited. Reds fall into three basic categories: intense orange-reds, such as vermilion and cadmium red; those with a bluish or rosy tinge, like alizarin crimson, carmine and rose madder; and brownish reds, including Mars, Indian and Venetian reds.

Cadmium red and alizarin crimson are widely favoured as the red ingredients of a basic colour palette. The intensity of cadmium red is often preferred to vermilion, although the latter is an attractively pure, bright colour and a good mixer. The orange bias of cadmium red or vermilion is useful for mixing oranges and rich browns. The bluish tones of alizarin crimson are preferred for mixing violets and purples, and it is usually preferred to rose madder, which is similar in hue but weak in colour mixes. Carmine and rose reds can be useful secondary mixers where clear magenta and red-violet hues are needed.

Alizarin crimson cannot be used in acrylic bases, and acrylic crimsons are typically less "blue", sometimes having a distinct brownish undertone. Nor is it used in soft pastels; the range of reds in this medium varies from cadmium red and vermilion to rose madder, and there are also intermediary hues that may have names such as poppy or geranium red, which are typically mid-toned and relatively bright.

Notes

Many of the pigment names remain the same from medium to medium. Where they differ, the nearest equivalent colour has been chosen.

A few colours bear the name of the manufacturer (i.e. Rowney orange). Similar colours are usually available in other ranges.

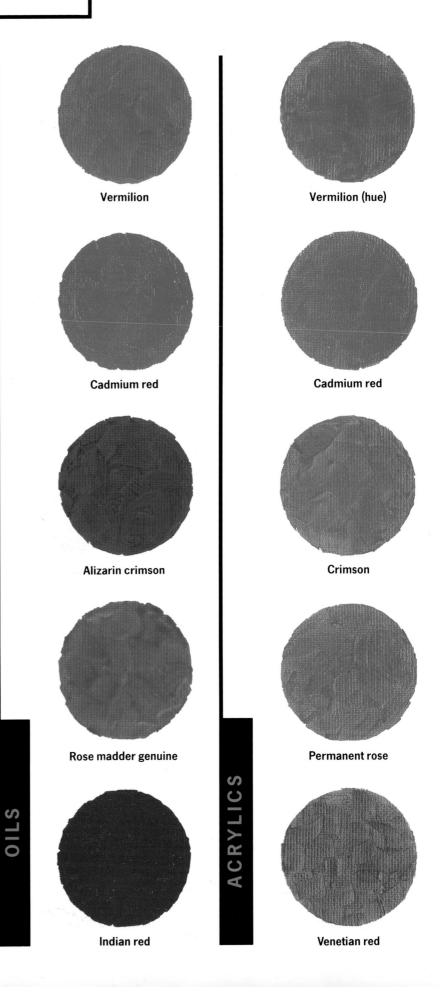

OILS

Vermilion

Cadmium red

Alizarin crimson

Rose madder genuine

Indian red

ACRYLICS

Vermilion (hue)

Cadmium red

Crimson

Permanent rose

Venetian red

Vermilion

Vermilion

Vermilion (hue)

Cadmium red

Cadmium red (hue)

Cadmium red (hue)

Alizarin crimson

Crimson

Crimson lake

Rose madder genuine

Alizarin rose madder

Rose madder

WATERCOLOR

Indian red

GOUACHE

Indian red

PASTELS

Indian red

YELLOWS

Because yellow is a naturally light-toned colour, the deeper shades tend toward orange, green or brown rather than yellow. Lemon yellow is the most popular "cool" yellow, a pale colour with a greenish tinge, while cadmium yellow is the standard bright, warm "sunshine" yellow. Another standard shade is the dark, warm yellow ochre, useful for earthy tones in landscape and yellowish flesh tints, and for mixing neutral colours and muted greens.

Aureolin, usually available only in watercolour and oil paints, is an interesting colour, seeming rather dull in the tube, but becoming brighter and very translucent when brushed out. Naples yellow varies from range to range more than most colours, in some appearing pale but quite rich and warm, in others light-toned and slightly greenish. It is valued, however, as the most opaque of the yellows, particularly useful for mixing flesh tints. Indian yellow, another strong, sunny shade, has a curious history, being originally manufactured from the urine of cows fed on mango leaves. This caused suffering to the animals and the "natural" source was banned: Indian yellow is now artificially prepared.

Acrylic and gouache colours include bright, clear hues in the middle range between lemon and cadmium yellows, sold under names such as permanent yellow, brilliant, spectrum or process yellow. Whether they are more or less useful additions to your basic palette is a matter of personal preference.

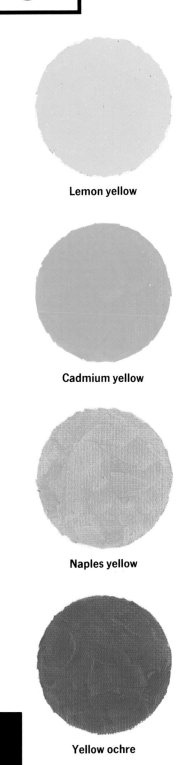

Lemon yellow

Cadmium yellow

Naples yellow

Yellow ochre

OILS

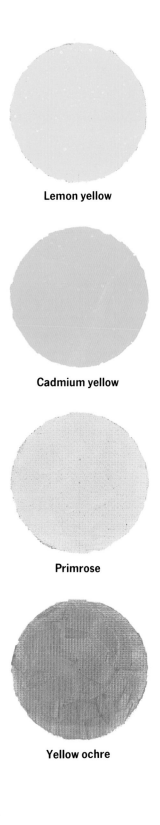

Lemon yellow

Cadmium yellow

Primrose

Yellow ochre

ACRYLICS

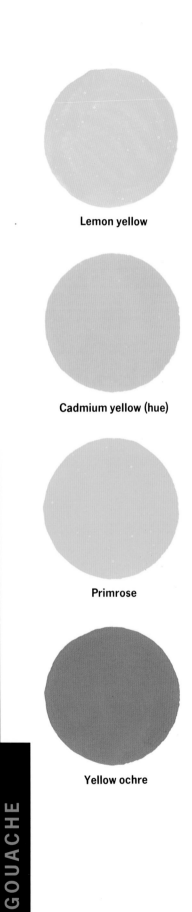

WATERCOLOR

Lemon yellow

Cadmium yellow

Naples yellow

Yellow ochre

Lemon yellow

Cadmium yellow (hue)

Primrose

Yellow ochre

GOUACHE

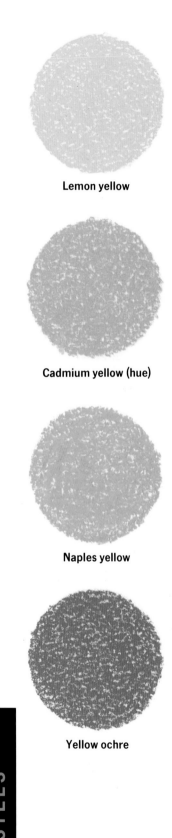

PASTELS

Lemon yellow

Cadmium yellow (hue)

Naples yellow

Yellow ochre

ORANGES

The available range of true orange paint colours is extremely small, but since most are in any case mixed pigments, you can obtain equally satisfactory colours by mixing reds and yellows on your palette. But the visual qualities of orange are equally restricted; it rapidly shades into appearing as another colour – yellow, red or brown.

Cadmium and chrome oranges are standard hues, cadmium being basically a red-orange and chrome a yellow-orange (chrome orange deep is redder). In oil, watercolour and acrylic paints, these are reasonably clear and strong. Chrome orange is the more opaque pigment, less permanent than cadmium orange, and may react badly in mixtures. In gouache, the orange tube colours flatten and dull slightly as they dry, mainly because of the paint's opacity and faintly chalky finish. In pastel, orange pigments can come up very fresh and bright, especially on tinted paper, but the lighter tones tend towards yellow or pink.

Cadmium orange

Cadmium orange

Chrome orange

No equivalent

Rowney orange

Rowney orange

OILS

ACRYLICS

Cadmium orange

Cadmium orange (hue)

Cadmium orange

Chrome orange

Tangerine

Cadmium tangerine (hue)

Chrome orange deep

Middle orange

Cadmium red orange (hue)

WATERCOLOR

GOUACHE

PASTELS

BLUES

Blue, like red, is a very strong area of the colour spectrum, and blue pigments can be extremely rich and dominating colours. Blues also provide a broader tonal range than most colour families, from bright cerulean blue to heavy, dark Prussian blue. Cerulean (sometimes called coeruleum), which has a strange yellowish tinge, is a useful colour for painting skies: indeed the name derives from the Latin *caeruleum* meaning a sky-blue colour. It is a semi-opaque pigment, unlike the other common blues, which are all transparent. Because of this transparency, a heavy coating of blue, even the darker ones like Prussian blue and ultramarine, may not completely cover up an underdrawing or previous paint layers. A small touch of white adds opacity without seriously affecting colour value.

Ultramarine is the most popular "warm", or reddish blue. It is a good mixer for purples and slightly subdued, natural-looking greens, so is often selected as the only blue in a limited palette. When mixed with white it has a mauve bias. Cobalt blue appears similar at full strength, but is usually less intense than ultramarine, and has a comparatively greenish undertone.

Prussian blue is a deep, powerful colour with massive tinting strength; in mixtures it must be cautiously added, as it easily floods pale and bright hues. With strong yellows, it makes beautiful, bright if somewhat artificial greens, but is less useful for purples, having a pronounced greenish undertone. Phthalocyanine blues, also variously marketed as monestial, monastral, thalo or Winsor blue, are similar and handled in the same ways.

Indigo is an attractive, dark, subdued blue, originally derived from a plant dye but now represented synthetically by a mixture of phthalo blue, ultramarine and black.

French ultramarine

Ultramarine

Cobalt blue

Cobalt blue

Coeruleum (or cerulean) blue

Coeruleum (or cerulean) blue

Prussian blue

Monestial (or monestral) blue

OILS

ACRYLICS

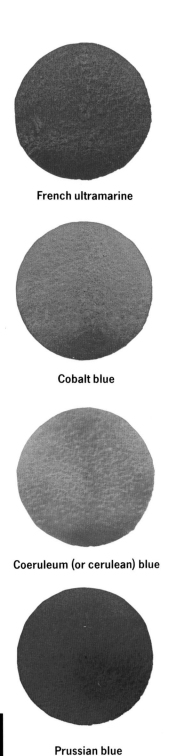

French ultramarine

Cobalt blue

Coeruleum (or cerulean) blue

Prussian blue

WATERCOLOR

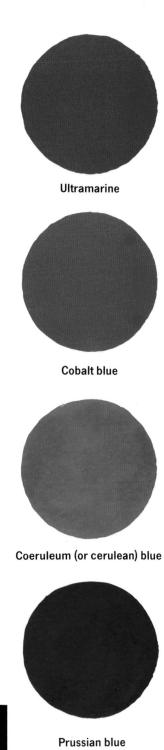

Ultramarine

Cobalt blue

Coeruleum (or cerulean) blue

Prussian blue

GOUACHE

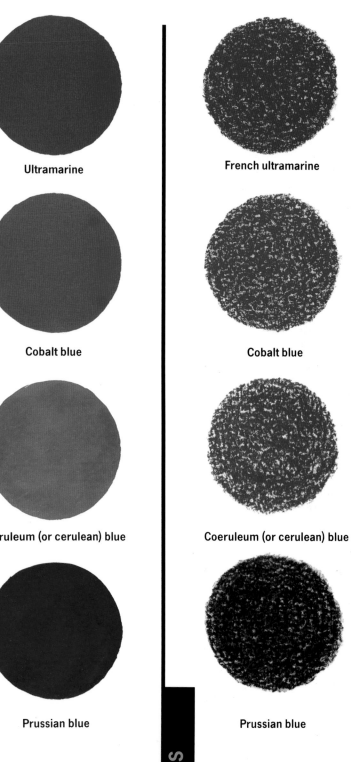

French ultramarine

Cobalt blue

Coeruleum (or cerulean) blue

Prussian blue

PASTELS

VIOLETS AND PURPLES

Although rich purple dyes were in use many centuries ago, reliable purple and violet pigments for artist's colours are quite a recent introduction. This section of the palette dates mainly from the introduction of synthetic pigments in the 19th century. Generally, they are few, and divide roughly between red-violets and blue-violets. It is useful to have at least one in your basic palette, because it is particularly difficult to mix vibrant, true purples.

The reddish shades include permanent magenta, cobalt violet, red-violet and purple lake; blue-violets include permanent mauve, deep violet and violet alizarin. There is some variation between media in both the appearance and naming of these colours, so you need to check what is available in the kind of paint you wish to use. Be alert also to manufacturers' ratings showing colours of doubtful permanence in this range.

Although most of these are relatively dark-toned colours, all are transparent pigments and often appear translucent when brushed out. Adding a touch of white increases opacity, but slightly dulls the hue.

Permanent magenta

No equivalent

Rowney red violet

Red violet

Cobalt violet

Permanent violet

Permanent mauve

Deep violet

OILS

ACRYLICS

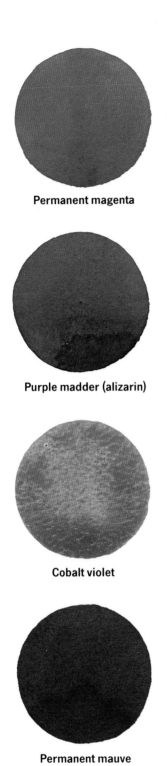

Permanent magenta

Purple madder (alizarin)

Cobalt violet

Permanent mauve

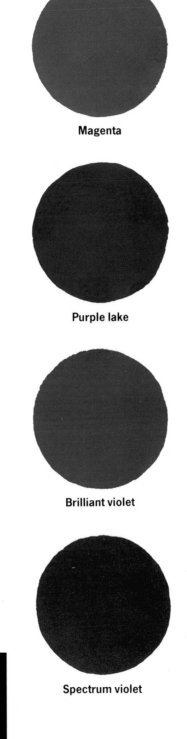

Magenta

Purple lake

Brilliant violet

Spectrum violet

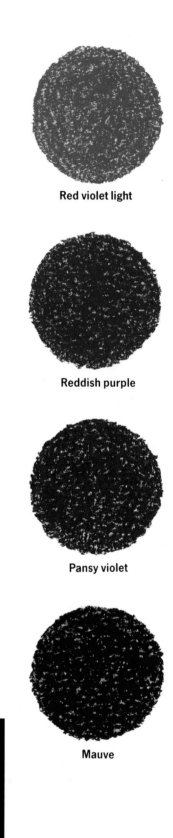

Red violet light

Reddish purple

Pansy violet

Mauve

WATERCOLOR

GOUACHE

PASTELS

GREENS

There are few natural green pigments and the wide range of artists' colours now available has developed since the introduction of synthetic pigments during the 19th century. Many green paint colours have an "artificial" appearance – they are vivid and strong, often composed from a mixture of pigments.

One of the most popular greens is viridian, a rich, deep, transparent colour, slightly bluish, that shades well in mixtures with yellow or blue and forms dense, dark-toned browns and neutrals when mixed with reds. It comes from chromium oxide and is reliably permanent. Monestial (monastral or phthalo) green is a very similar phthalocyanine colour used in acrylic, watercolour and oil paints. Hooker's green, slightly lighter in tone, is produced from mixed pigments so may vary between different paint ranges, tending more to blue or yellow.

Sap green is a mid-toned, more earthy, natural-looking green with a distinct yellow bias. It is a useful oil or watercolour hue, but only moderately permanent. Terre verte is a traditional earth pigment which is now synthetically simulated. Olive green is self-descriptive, sometimes available in deep and pale shades. Most of the deeper greens are transparent pigments, an exception being oxide of chromium green, a strong opaque colour.

The bright greens include cadmium, chrome and cobalt green, and more descriptively named colours such as emerald, light or bright green, and leaf green. The latter are typically mixed pigments, both their exact shade and their availability varying between different paint media.

Viridian

Monestial (or monestral) green

Hooker's green (No. 2)

Hooker's green

Sap green

Pale olive green

Chrome green

Opaque oxide of chromium

OILS

ACRYLICS

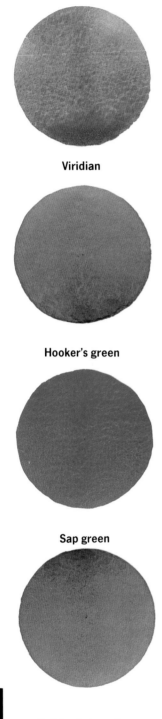

Viridian

Hooker's green

Sap green

Oxide of chromium

WATERCOLOR

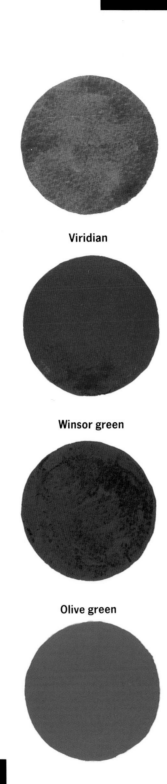

Viridian

Winsor green

Olive green

Opaque oxide of chromium

GOUACHE

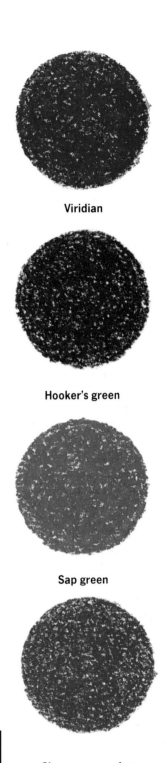

Viridian

Hooker's green

Sap green

Chrome green deep

PASTELS

BROWNS

The commonly used browns are natural earth colours derived from iron oxides. Red earths date back to prehistory, and appear in cave paintings, while umbers and siennas were developed in the 15th century. Raw sienna is a warm, mid-toned golden brown, deeper but more transparent than yellow ochre, which it resembles. Burnt sienna, made by roasting the raw pigment, is a very rich, strong red-brown with a warm red undertone. Raw umber and burnt umber have a similar relationship, but these are harsher colours; raw umber is greenish, burnt umber is warmer but darker and more opaque. All these brown shades are reliably permanent; earth colours are usually among the least expensive colours in paint ranges that have banded price categories.

Sepia is a dark and fairly neutral brown, a useful shader for neutral mixes. Pigment from the original source, shellfish, was unreliable, but modern equivalents are moderately permanent in watercolour and normally permanent in oil. Vandyke brown is a dark brown somewhat similar to burnt umber, originally derived from a natural earth compound which was not reliably permanent, but now matched by a mixture of more stable pigments.

There is a small range of red-browns and yellow-browns based on iron oxides, including brown madder (also called alizarin brown), Mars brown (reddish) and Mars yellow. Colours such as Indian red and Venetian red (see page 18) are in the borderline territory between red and brown.

Burnt sienna

Burnt umber

Raw umber

Vandyke brown (hue)

OILS

Burnt sienna

Burnt umber

Raw umber

No equivalent

ACRYLICS

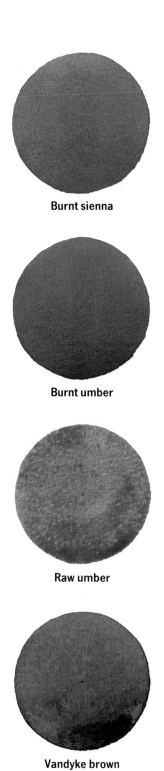

Burnt sienna

Burnt umber

Raw umber

Vandyke brown

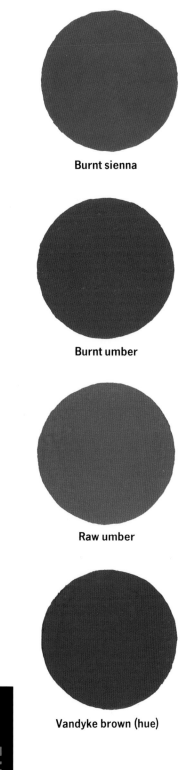

Burnt sienna

Burnt umber

Raw umber

Vandyke brown (hue)

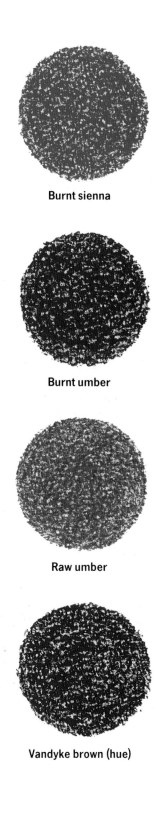

Burnt sienna

Burnt umber

Raw umber

Vandyke brown (hue)

WATERCOLOR

GOUACHE

PASTELS

BLACK, WHITE, AND GRAY

The blacks in general are opaque, fully permanent pigments derived from carbon, bone or iron oxides. Lamp black is carbon black, originally the sooty deposits made by burning oils and fats. Ivory black, the most widely used black pigment available in oil, watercolour and acrylic paints, is made from bone rather than ivory. Mars black is an iron-oxide colour, a very dense, heavy black. It is difficult to assign a colour bias or influence to blacks, but there are slight differences; for example lamp black seems slightly warmer than ivory black.

There are few true greys in paint colours, since both neutral and "coloured" greys are easily mixed. However, Payne's grey, a subtle, dark blue-grey, is a very popular colour particularly in watercolour painting.

Gouache paint ranges may also include more greys, sometimes differentiated as warm, cool or neutral greys.

One of the oldest-established whites, flake white, used only in oil medium, has been the subject of some controversy because of its lead content, but is so far still in use.

Zinc white comes from zinc oxide, as does the delicate Chinese white used for highlighting in watercolour painting. It is a clean, cold white, normally opaque. The most widely used white now is titanium white, derived from titanium oxide – the gouache colour permanent white comes from the same source. It is opaque and appears completely neutral, with no colour bias.

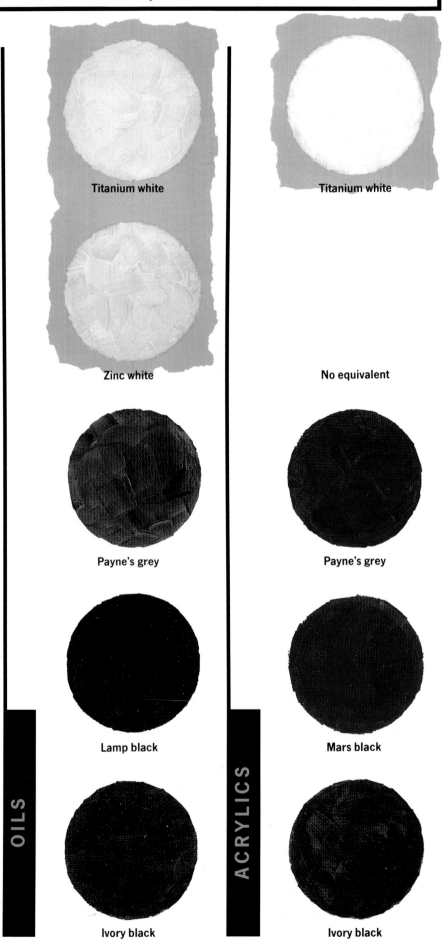

Titanium white

Titanium white

Zinc white

No equivalent

Payne's grey

Payne's grey

Lamp black

Mars black

Ivory black

Ivory black

OILS

ACRYLICS

No equivalent

Chinese white

Permanent white

Zinc white

Silver white (blue shade)

White (cream shade)

Payne's grey

Payne's grey

Blue grey

Lamp black

Lamp black

Lamp black

Ivory black

Ivory black

Ivory black

WATERCOLOR

GOUACHE

PASTELS

MIXING COLORS

Increasing skill in mixing the colours you need happens through practice, as you become more familiar with your paints and the range of mixtures they can produce. However, mixing on the palette is not the only important work being done; there are also ways of making colours work with more complexity on the surface of your painting. Both aspects of colour mixing are considered in the following pages.

Achieving an exact, mixed colour to match a colour in your subject can be a difficult task, and sometimes you arrive at a satisfactory mix on the palette only to find the colour appears different when brushed out, or dries differently. Successful colour work, even in strictly representational painting, is not necessarily a straightforward matter of matching colours as you observe them. Interactions between hues and tones as they are laid down on the working surface can influence the apparent values of individual colours, and it is sometimes advisable to exaggerate or enhance particular qualities to make a picture more descriptive. Those elements are discussed later, in relation to colour relationships and pictorial considerations.

EFFECTS OF MIXING

Because pigments are solid substances, the colour ingredients do not physically mix when you mix two or more paint colours; they mingle. If you imagine the pigment as a sort of fine grit floating in the liquid medium, you can visualize the effect of adding more colours. There are more different-coloured particles jostling about, and like people in a crowd, the more of them there are, the more difficult it is to appreciate

▼ Acrylics

Acrylics dry quickly and once dry are no longer water-soluble, so lay out the colours only as you need them. A palette knife is sometimes more efficient than a brush for mixing large amounts of thick paint. A sheet of heavy glass or a plastic-faced board makes an ideal palette for acrylics.

▲ Watercolours

Tube watercolours may need to be heavily diluted and it is essential to use a ceramic or plastic well palette that enables you to lay out the colours cleanly, keep the mixed colours separate from the unmixed, and add the required amounts of water to create colour washes in quantity.

▼ Oils

Treated wooden palettes are traditionally used for oil paints. Many artists lay out their colours in a sequence, such as light to dark, along the edge of the palette and mix into the middle. You usually need a larger quantity of white than of other individual colours, but all remain moist on the palette for some time and can be used up gradually.

◄ Gouache

Well palettes are most suitable for gouache, so you can mix colours thickly direct from the tubes, or dilute them into washes. Gouache is relatively quick-drying, but unlike acrylic paint can be softened and brushed out with water when it begins to dry on the palette.

individual identities. In painting terms, overmixing tends to make a "soup" of indeterminate colour.

The kind of mixed colour you will obtain from particular combinations depends basically upon whether the colours are like or unlike, and what biases or undertones they have that may be introducing an element of yet another colour. The following are basic principles that will apply when you mix two colours only:

● Mixing two hues from the same colour family results in a relatively pure, clean hue that combines their characteristics. A mix of two reds produces another slightly different red, and so on.

● Mixing two separate hues from different families in certain cases will produce a clean combination that makes a third colour of distinctly individual character – such as yellow and red for orange, yellow and blue for green.

● Mixing two hues that are directly related or share some colour quality gives a third, intermediate hue that may tend to one or another of the original components. For example, blue and green form a blue-green or green-blue, with no devaluation because blue is a component of green. Red and red-violet produce a redder violet or a violet-tinged red.

● Mixing two hues that are visually unlike results in a

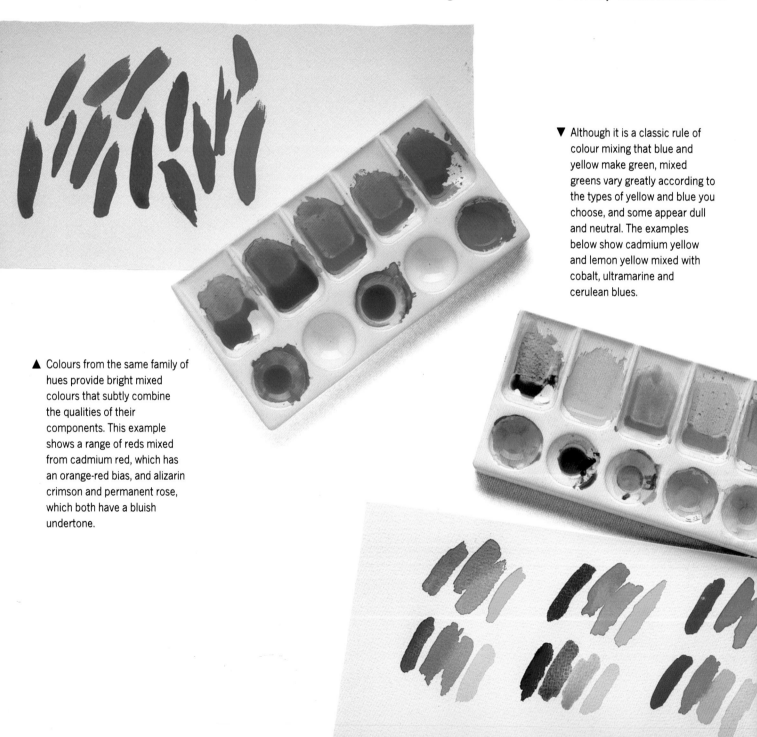

▼ Although it is a classic rule of colour mixing that blue and yellow make green, mixed greens vary greatly according to the types of yellow and blue you choose, and some appear dull and neutral. The examples below show cadmium yellow and lemon yellow mixed with cobalt, ultramarine and cerulean blues.

▲ Colours from the same family of hues provide bright mixed colours that subtly combine the qualities of their components. This example shows a range of reds mixed from cadmium red, which has an orange-red bias, and alizarin crimson and permanent rose, which both have a bluish undertone.

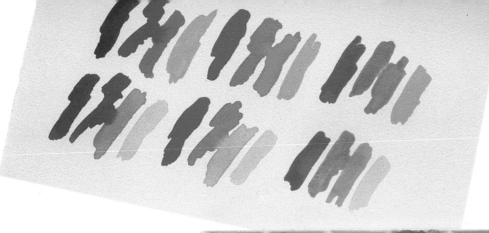

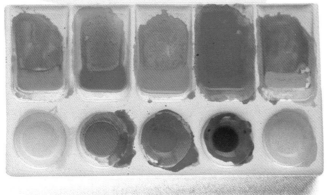

◀ Like greens, mixed oranges vary considerably depending on the red and yellow chosen as mixers. Cadmium red and cadmium yellow, which are both bright, orange-biased hues, make vivid orange (centre top). Likewise, vermilion and cadmium yellow (top right) produce an intense orange, whereas the cooler, greenish undertone of lemon yellow (bottom row) reduces the intensity, as does the bluish tinge of alizarin crimson (far left).

▶ Brownish-purples are the natural result of certain types of red mixed with blue – for example, cadmium red (far right) and vermilion. Each of the reds in this sample is mixed with ultramarine (top row) and cobalt blue (bottom row). The true purples must be based on bluish-reds, such as permanent rose (right) and alizarin crimson (centre right).

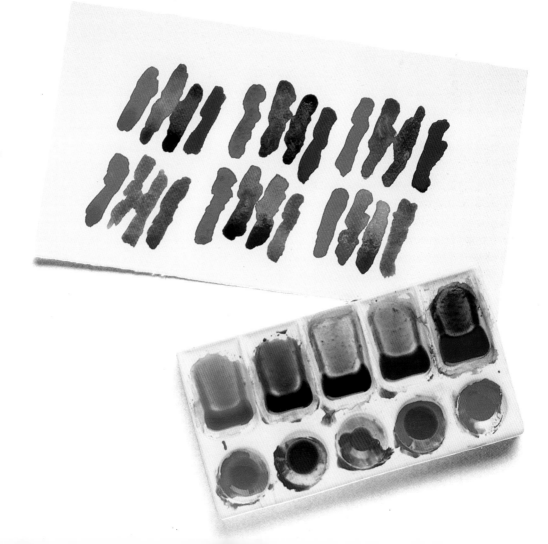

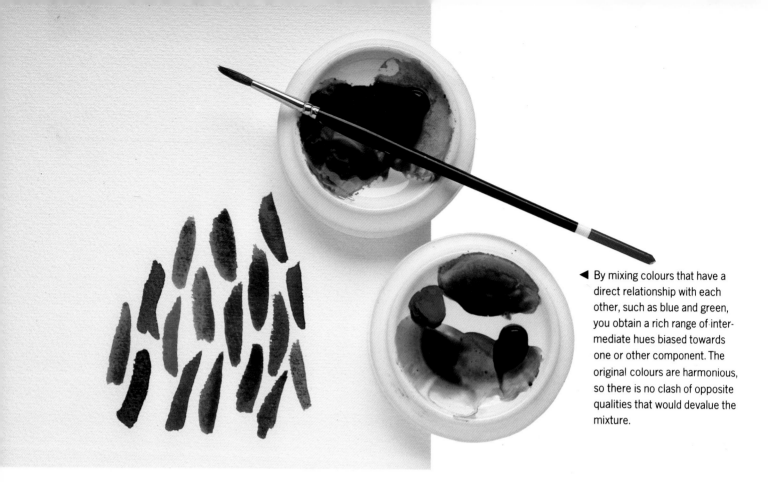

◀ By mixing colours that have a direct relationship with each other, such as blue and green, you obtain a rich range of intermediate hues biased towards one or other component. The original colours are harmonious, so there is no clash of opposite qualities that would devalue the mixture.

quite different, usually neutralized colour. Certain kinds of red and blue make violet, but often a blue-red mixture forms a kind of brown. Blue-and-orange or red-and-green mixes make shades of brown. Yellow and violet mixes make a kind of dark yellow or mauve-grey, depending on proportions in the mix, or a brownish colour if the violet is biased to red.

● Mixing a hue with white or black lightens or darkens the colour, but it may also change it to produce another kind of colour. Red and white, for example, produce pink; red and black make brown; yellow and black make green. A tint made by adding white, however, has a colour value different from that of a lighter tone of the original hue made by diluting the paint; and the addition of black can deaden the "colourfulness" of the hue's influence in the mixture.

When you start to make mixtures that contain three or more colours, the results more rapidly become muddy and less colourful. This is partly because the different pigment particles are partially "masking" each other, and partly because you are likely to be mixing colours that are unlike, or have dissimilar characteristics. If you mix a tube green with some yellow and blue, you may obtain a different, perfectly acceptable shade of green. But if the yellow is orangey, you are introducing a touch of red that "opposes" the green and takes down its vibrance and intensity. Three- and four-

colour mixes can produce interesting neutrals, however, and if white is one of the components, you obtain the range that we describe by terms such as beige, buff and "coloured greys".

Broadly speaking, however, if you are trying to mix a colour that has a clear identity within the main family groups – red, violet, green, etc – you should need no more than two or three component colours. A simple practical point to keep in mind is to avoid contaminating mixes by inadvertently introducing additional colour from a dirty brush or water jar. It may seem that the amounts you can add that way are relatively trivial, but they all contribute to muddying the colours that you have actually selected. Rinse and blot your brushes whenever you change colours, and freshen your water or turpentine frequently.

MIXING ON THE WORKING SURFACE

When you think of the practice of mixing colours, it is natural to imagine mixing on the palette. However, there are many ways in which colours are mixed on the working surface, either deliberately or inadvertently, and you can learn to control these and use them to your advantage. The simplest form of surface mixing is a blend of colours, where you put down two distinct colour areas and brush them together so the junction is

◀ When you mix colours that are quite unlike each other, that is, have no obvious direct relationship, the result is a devaluation of the intensity of both, creating a neutralized mixture. The darker the original colours, the more dense the effect. These examples show (from left to right) Prussian blue and Indian red, Prussian blue and alizarin crimson, Hooker's green deep and Indian red, mauve and Hooker's green deep, mauve and raw umber.

▶ As mixers, black and white do not simply lighten or darken a colour, they can appear to alter not only its intensity but also the bias of the hue. In these examples, the blue is least affected, and both the light and dark tones can be seen to relate directly to the original hue. Yellow, since it is naturally light-toned, is completely altered by the addition of black, which turns it to dull green. Mixing with white can seem to bring out a slight bluish tint in red, while black and red invariably produce brown.

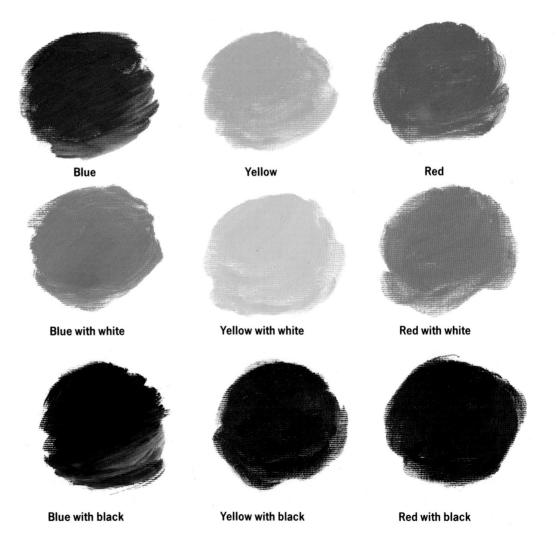

Blue **Yellow** **Red**

Blue with white **Yellow with white** **Red with white**

Blue with black **Yellow with black** **Red with black**

not hard-edged – naturally creating an intermediary hue or tone. This is such an instinctive process in working with oils, acrylics or gouache that you would not necessarily think of it as positive mixing. Laying one wash over another in watercolour painting, or one pastel colour over another, are more deliberate processes, and you will probably be more conscious of likely effects of colour mixing in this way.

BROKEN COLOR

The term "broken colour" is applied to the effects obtained by a variety of techniques whereby colours applied individually to the working surface appear to merge and mix. It is classically used in pastel painting, where the dry medium does not allow pre-mixing. Blending on the working surface tends to deaden the colours; instead a network of marks representing individual strokes of the pastel sticks is built up into the appearance of broad colour areas and shaded masses. It is similarly typical of modern, impressionistic painting techniques in which individual brushstrokes are made to cohere in the same way. An area of sky, for example, may appear from a distance as an overall clear, light tone, but seen from close to many shaded and textured colour interactions become apparent.

The basic principle at work is that of optical mixing – that a mass of individual colours mixes "in the eye" to form the expected hues and tones. For example, an area randomly broken with dashes and dabs of blues and yellows "reads" overall as green; or actual greens

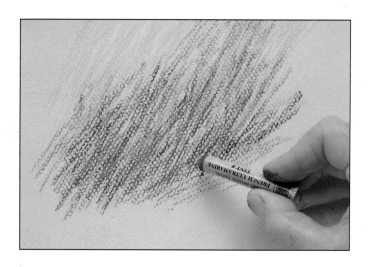

Pastel: linear blending Fine pastel strokes meshed together and built up into a dense colour mass produce an effect of optical mixing.

might be shaded and varied by the interactions of blue, yellow or red marks. The ingredients of such a mixture are the same as you would use in palette mixing, and conform to approximately the same guidelines – the more colours you add, the more neutralized the apparent mix becomes. But the theory behind optical mixing is that more brilliant effects are obtained than when colours are mixed on the palette, because pigments are not masking each other and the vibrancy of individual hues is subtly active even while the mixed effect is perceived.

Broken-colour effects can be very rough, irregular and variable or quite detailed and systematic. Where they derive from a generalized technique, the individual marks come more or less randomly from the shapes and sizes of the brushes or pastel sticks, the gestures the artist makes and the range of colours applied to a given area. Alternatively, a controlled technique such as stippling or drybrushing can be used to limit both the range of marks and the colour ingredients, aiming for a specific effect that can provide very clearly defined colour mixtures and tonal modelling.

Although broken colour techniques originated with oil painting, it is perhaps easier to keep colours clean and separate while building up the textured surface if you are using dry pastels or water-based paints that dry quickly. But acquiring the right touch to avoid clumsy blending or pick-up from underlying colours does come with practice, and some artists find that they instinctively prefer to work in rapid separate strokes rather than brushing in broad areas and blended textures. The personal value of this method is a matter of both preferred technique and pictorial style.

Optical mixing
The colours used in this study are orange, green, yellow, red, blue and white. Instead of pre-mixing to produce shading and colour variation, all the mixing occurs visually, where stippled marks in different colours appear to blend.

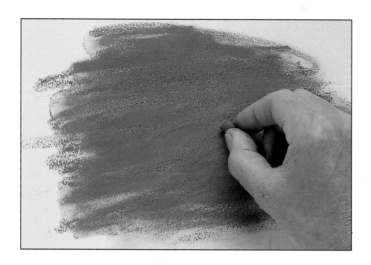

Pastel: side strokes Create broad masses of grainy colour by sweeping the edge of the pastel stick over the paper. Colours can be combined and blended by this technique.

Pastel: coloured ground Working on coloured paper is a traditional technique, so the ground contributes an element of colour that affects the applied colours' intensity.

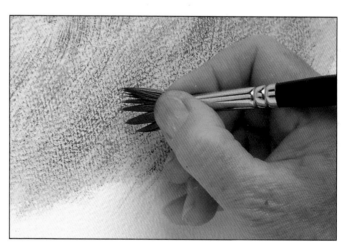

Watercolour drybrushing 1 Mix up a strong wash of colour and load your brush. Blot the brush on a paper towel or rag.

2 Spread the hairs of the brush between your finger and thumb and drag the tips across the paper, laying down a fragile, broken texture.

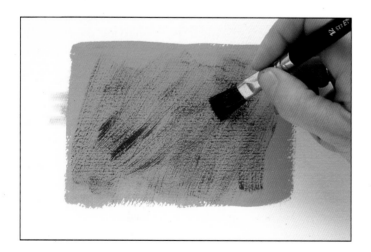

Gouache drybrushing 1 Load the brush with colour and blot off the excess. You can spread the bristles as for watercolour, or work in rapid, light strokes.

2 You can repeat the technique using different tones and colours to build up a heavily textured surface in which the colours modify each other.

Acrylic glazing 1 Dilute acrylic colours with plenty of water and brush them out thinly on the paper.

2 The thinned paint quickly dries, and you can almost immediately begin to overlay glazes of different colours.

3 As the colours build up, they modify each other and produce mixed hues. As dried acrylic does not dissolve, the edges of the brushstrokes remain visible.

LAYERING

Certain broken colour effects come from colours laid down side by side, while others can involve a greater degree of layering. If the paint is opaque, broken layers tend to look like juxtaposed marks until you get close enough to identify the sequence of colour applications. But by layering transparent washes or glazes of colour, you can obtain very clear, rich mixed-colour effects that have a beautiful depth and transparency.

Glazing is a traditional method in oil painting. It can be a slow and laborious process because of the time the paint takes to dry, but special mediums are now sold for oil-paint glazing, which not only thin the paint and make it more transparent but also cut down the drying time. The approach works particularly well with acrylic paints, which produce glossy, bright glazes when thinned. The method can also be used with transparent watercolours, but is not suited to gouache because it is too opaque.

With acrylics, the glazed layers dry immediately provided you do not let the watery paint "puddle" on the surface, and you can rapidly overlay different colours and tones. The technique works equally well on paper or canvas, although canvas absorbs the wet paint initially and it may take a little longer to build up glossiness and depth of colour.

When overlaying watercolour washes, you need to cultivate a light touch, as the paint remains water-soluble and there is a risk of picking up or brushing out the colour underneath when you apply a new layer; but you can overwork very cleanly, allowing a little waiting time for drying if the paper becomes saturated with moisture. If you are using either acrylic or water-colour on paper, it needs to be stretched on a board, as otherwise it will buckle irretrievably.

With either glazes or overlaid washes, you need to plan the painting to work from light to dark, building up the strong tones and intense colours gradually. To lay a clean, light tone over a dark one, you would have to use opaque paint containing white, thereby con-cealing the underlayer and losing the transparency. With acrylics, you can return to glazing transparent colour over opaque, but this does not work well with watercolour.

Scumbling is the deliberate use of semi-opaque colour to "veil" rather than glaze the effect of an under-layer. Usually the colour is applied with a scrubbing motion of the brush, so that it combines characteristics

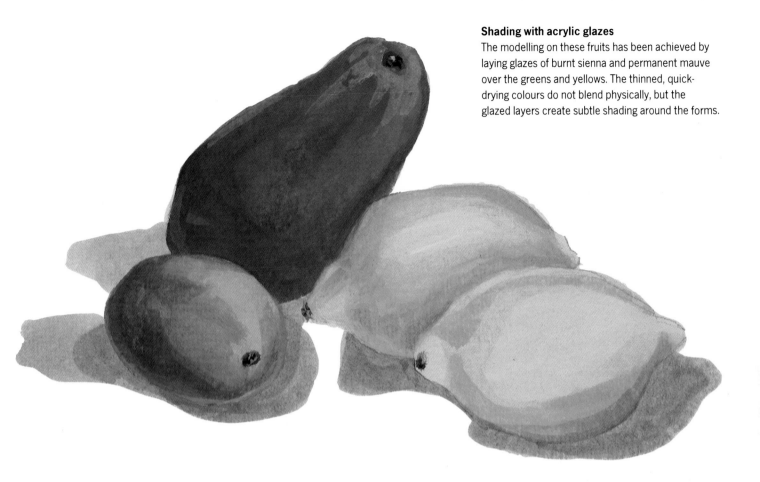

Shading with acrylic glazes
The modelling on these fruits has been achieved by laying glazes of burnt sienna and permanent mauve over the greens and yellows. The thinned, quick-drying colours do not blend physically, but the glazed layers create subtle shading around the forms.

of drybrushing and glazing. This can provide light over dark tones and subtle modifications like "greying" of pure colours that have a very attractive, atmospheric feeling. It is an effective technique for oil and acrylic painting and soft pastel work.

Pastel artists also use a version of the glazing technique. This works differently from glazing with paint, because the pastel colour is opaque. It consists of lightly sweeping the broad side of the pastel stick across a heavily toothed paper. The colour is deposited thinly and quite evenly on the ridges of the paper grain, creating a semi-opaque layer.

Scumbling With an opaque medium, this is effective for veiling dark colours with pale tone. Use thinned paint and move the brush quickly and lightly over the surface.

Pastel glazing Apply the pastel stick on its side in sweeping strokes, letting the paper grain pick up an open mesh of colour. You can blend colours gradually this way.

Oils

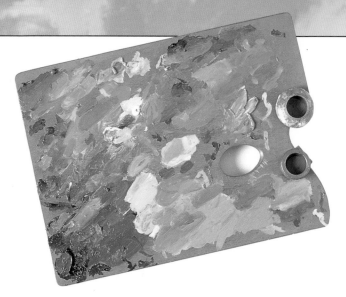

Oil paint is a substantial but slow-drying medium, so although you can mix colours accurately and apply bold, opaque strokes, you need to work methodically to avoid mixing and muddying the colours on the canvas. James

Horton uses a broken colour technique, putting down dabs of colour side by side to achieve the variations of hue and tone gradually.

1 The composition is sketched out with a thinned mixture of raw umber and Indian red. The artist begins directly to set up an overall colour balance, blocking in the local colours of the objects with small brushstrokes. For the mid-toned colours – the blues, greens and reds – he introduces slight tonal variations to suggest light and shadow.

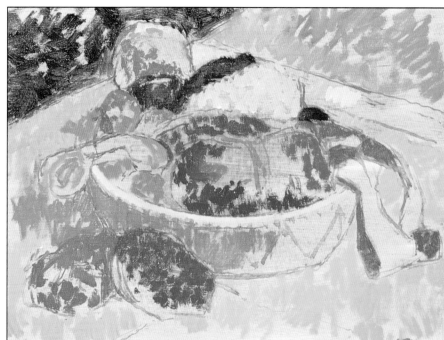

2 The same process continues until the image area is gradually covered with colour. Variations and contrasts are emphasized by using different colours for the mixing base; for example, cerulean blue for the green-blue and ultramarine for the mid-blues and purples. Similarly, the artist offsets the cool bluish-pink made with alizarin crimson and white with a "hot" tint based on cadmium red.

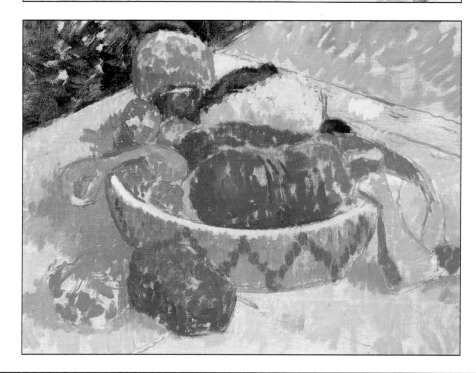

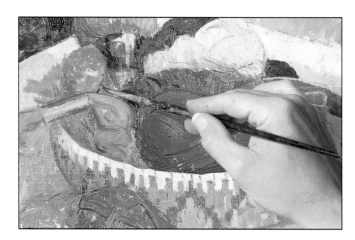

3 The artist continues building up with small strokes until all the shapes are blocked in with a solid layer of colour. He then uses longer and broader strokes to blend the tones within each colour area, helping to model the forms. Linear detail suggesting the texture of the wool is over-painted with a fine, pointed sable brush.

4 The pattern on the tablecloth is finely traced, and the cast shadows on the left of the basket are strengthened using a neutral tint mixed from raw umber and titanium white, modified with cadmium orange or with ultramarine to deepen the shade. Minor adjustments are made where necessary to enhance the tonal structure.

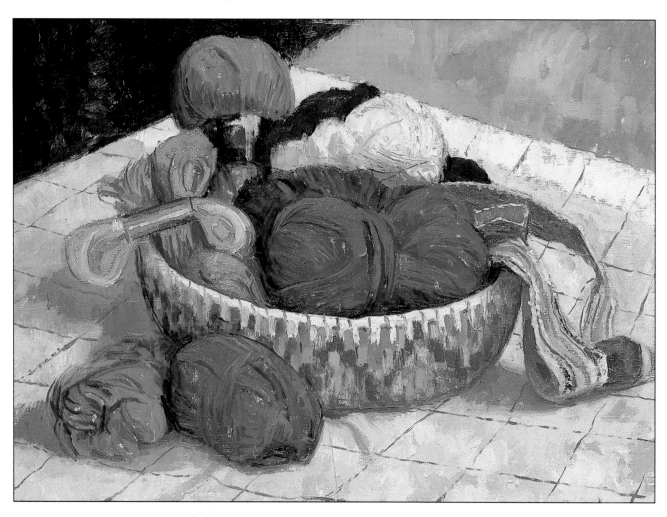

5 In the final stage, the artist works in loose, vigorous strokes, adding vibrancy to the bright hues and depth to the shadow colours. Subtle colour contrasts are brought out more strongly, such as the juxtaposition of blue-green with yellow-green, and blue-purple against violet, in the two balls of wool placed in front of the basket.

Acrylics

Acrylic colours are strong but not subtle, and it can be difficult to match certain hues by mixing tube colours. For this subject the blues and greens were easier to mix than the lilac, pinks and yellows, which lacked vibrancy at first. Another problem of acrylics is that dark colours are relatively transparent, but adding white to give opacity can deaden the hue. Judy Martin overcame these problems by combining transparent and opaque paint layers to build up the modelling and brighten the colours.

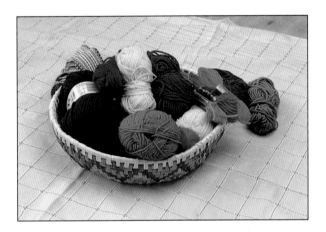

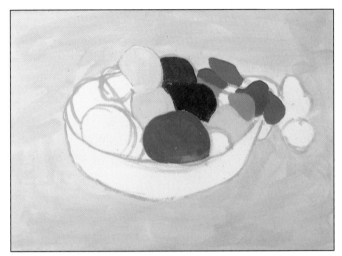

1 The artist begins by sketching out the full subject with the brush and blocking in the local colours. The first colour mixed corresponds to the pink background, and is used both for the drawing and to cover the background. This sets a key for the colours of the wools, which occupy a full range of hues and tones from dark purple to pale yellow.

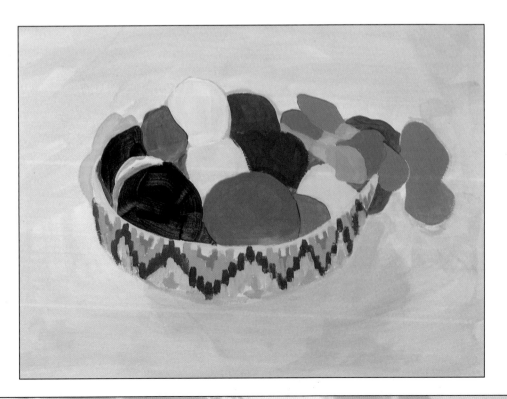

2 Even at this early stage, brushstrokes are used to suggest variations of texture, particularly noticeable in the basket, painted with individual, small strokes, and in the loosely brushed curves on the dark blue ball of wool. Most of the local colours are now quite accurately matched, although the hot pinks are difficult to obtain from acrylic crimson, which is not a vivid hue. But the overall effect so far is rather dull because contrasts are underplayed.

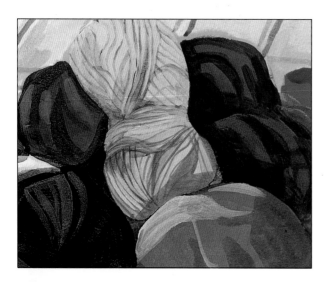

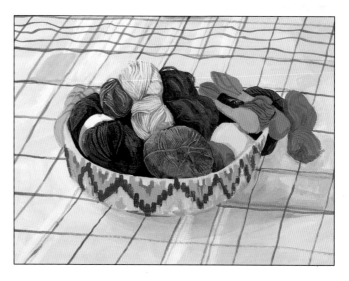

3 To model form and texture, the blues are shaded with deep violet, the green and purple with ultramarine. Highlights are made pure white, to be over-glazed with colours later. Light and dark tones of violet describing strands of wool make the lilac shape appear stronger and brighter.

4 Linear drawing with the brush is combined with glazing techniques throughout to develop the modelling. Glazes of pure hues over white highlighting makes the greens, blues and purples more vivid. Shadow areas are also thinly glazed, allowing the underpainting of local colour to show through.

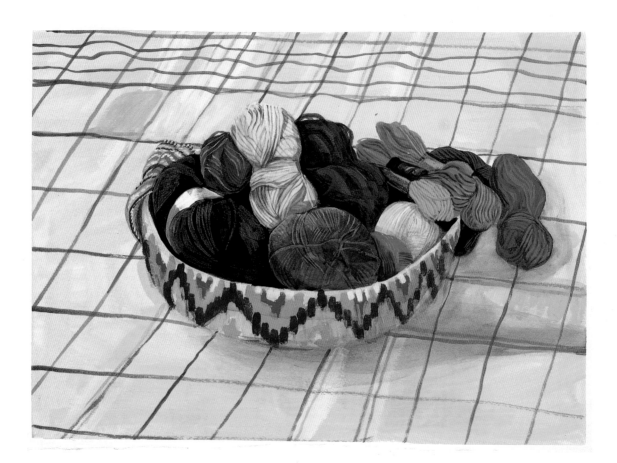

5 As each colour area is built up more strongly, the colours interact more vibrantly. With "difficult" colours like the brilliant magenta pinks, which cannot be matched exactly by mixing red and white, the artist has exaggerated tonal contrasts and overlaid thin glazes of pure crimson to simulate the brightness of hue.

Watercolor

Watercolours are transparent and jewel-bright, softening beautifully when diluted but acquiring full strength with successive layered washes. Hazel

Soan demonstrates how you can model tones and colours in gradual stages, keeping highlights clean and bright.

1 Classic watercolour technique means building up from light to dark. To preserve highlight areas, the artist first paints them with masking fluid to protect the white paper while the colours applied. She applies low-key washes of alizarin crimson to define shadow areas.

2 In the second layer of washes, she starts to establish the local colours of the wools and basket. On the right, she has used yellow ochre on the braid and basket and ultramarine to draw the strands of yarn on the blue ball, then shades of blue-purple and violet mixed from ultramarine and crimson for the dark blue and purple balls.

3 After the washes have been strengthened to develop tonal contrast that models shape and detail, the painting is allowed to dry and a kneadable eraser is used to lift the dried masking fluid from the highlights.

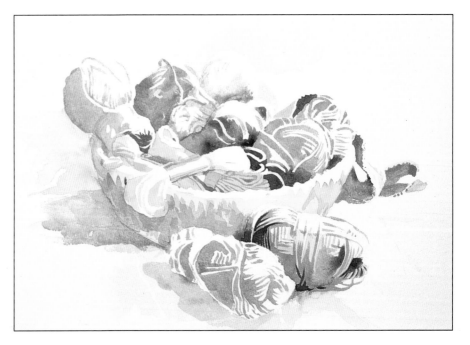

4 The green wool and parts of the basket are shaded with a subtle green-grey mixed from yellow ochre and ultramarine. The artist pays careful attention to the thickness and direction of the brush-strokes to create an impression of the different textures in the still life.

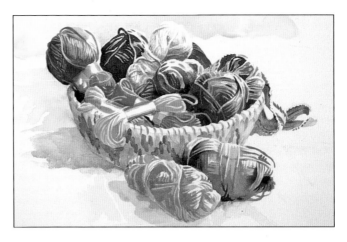

5 With the tonal range contributing a clear sense of form and texture, the local colours can be more strongly identified. The three shades of vivid pink are heightened using alizarin crimson and Winsor red, the greens with sap green and Hooker's green dark, modified with cerulean blue to make the blue-green.

6 A wash of yellow ochre across the background slightly lowers the overall key of the painting, so the deeper tones are correspondingly strengthened. This also enhances the contrast of light and dark, giving the forms a more rounded, solid feeling.

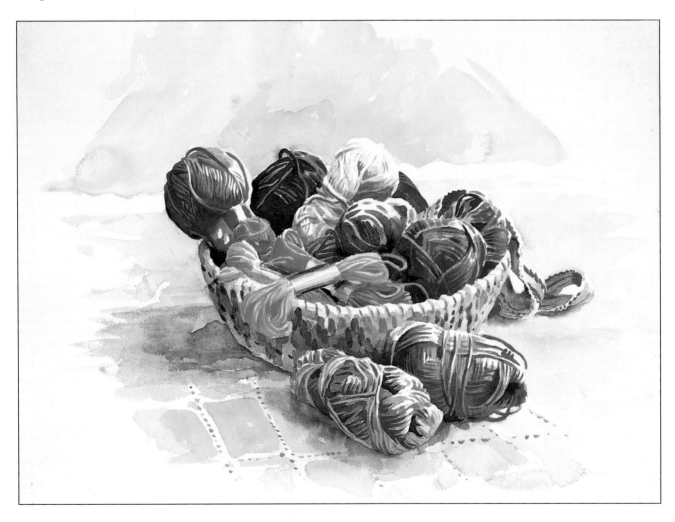

7 In the final painting, the artist has more fully developed the colour range in the foreground. The yellows and greens stand out vividly against the warm pink of the patterned tablecloth and the deeper purple washes are used to intensify cast shadows.

Pastels

The obvious difference between pastels and the moist paint media is that you cannot pre-mix colours. This does not mean that you have to find individual pastel sticks to match every variation in your subject, but you do need to create equivalent values of light and dark tone, brilliant and muted hues. In Hazel Harrison's pastel painting, linear marks and grainy side strokes gradually mix and blend on the paper surface.

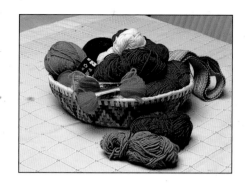

1 The artist chooses to work on a light buff-coloured paper, which gives a softer background for keying the colours than pure white paper. She sketches out the still life loosely with a neutral grey pastel, then starts roughly blocking in areas of local colour, but even at this early stage modifies her colours towards the light and dark tones that give form to the objects.

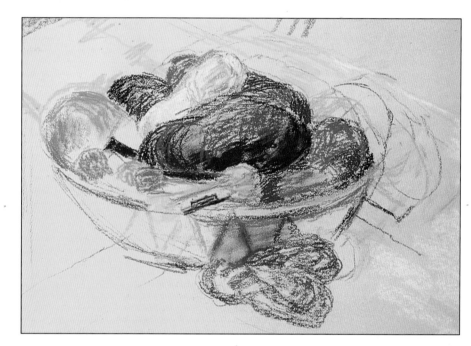

2 As the painting progresses, the artist pays attention to accentuating the biases of the hues. She achieves the variety of blues, for example, by selecting shades of cobalt for the right-hand ball of wool, ultramarine at the back, and cerulean and turquoise on the left. However, the dark-toned colours used for shading are less variable and help to unify different parts of the painting.

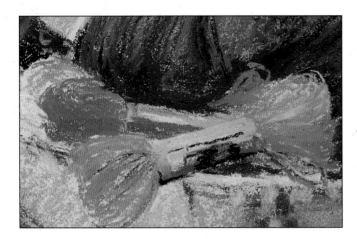

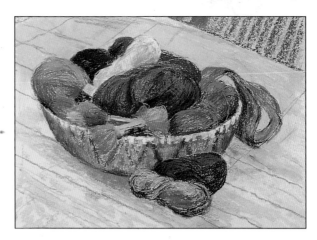

3 The colour interactions are becoming more complex; brownish shading in Indian red gives intensity to the dark pink skein of wool, while the vivid mid-pink is modified with red-violet. These colours are not an exact match for the real colours, but create the right balance of hues.

4 The weight and texture of the pastel strokes is an important aspect of making the colours work effectively. Because pastel is opaque, you can work light over dark and vice versa. Fine linear strokes mesh easily, more emphatic broad strokes heighten the colours and texture.

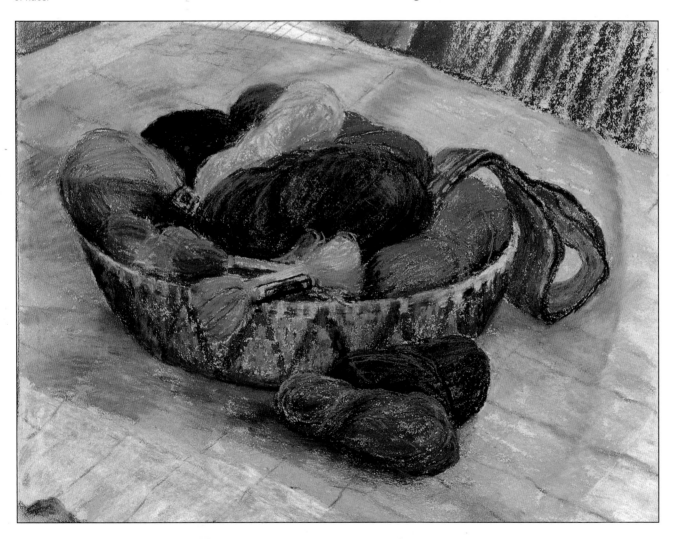

5 Having built up the warm pinks and browns representing the patterned tablecloth and cast shadows, the artist makes a number of finishing touches to adjust the overall tonal balance. Light colours are intensified, and offset by subtle shading with cool, mid-toned blues and purples.

Color interactions

As you gradually develop the range of colours in a painting, you will find that the appearance of individual colours seems to change each time you introduce a new element. Colours are relative; they interact and react to one another on the working surface. Although pigments are standardized to create reliable colour values, the visual qualities of any colour are influenced by the context in which it is seen.

Colour theories that were devised during the 19th century were an attempt to give colour analysis a scientific basis, so that using colour could be a more controlled and predictable exercise.

The following sections explain basic theories of colour relationships. These can help you to make colours work more effectively in your paintings, but they are intended to provide guidelines, not rules. Although they are open to creative interpretation, they do reveal some of the principles by which artists can use colour purposefully to structure an image or enhance its expressive qualities.

THE COLOR WHEEL

This diagrammatic arrangement of colours can be laid out in various different forms, but the colour relationships it describes are standard. It is based on the idea of pure colour values which derive from three primary colours – red, yellow and blue. These are defined as the primaries because they are colours that cannot be mixed from combinations of other colours. They are unlike each other, and none contains any element of the other primaries.

T he primary colours are located on the wheel at equal distances from one another. Between them fall the secondary colours – orange, green and purple – which represent mixes of primary pairs. Between the primaries and secondaries are intermediate colours, red-orange, yellow-orange, yellow-green, blue-green, blue-purple and red-purple, each representing a mixture of the adjacent primary and secondary.

Depending on the size of the wheel and the number of subdivisions, these could be split once again into further intermediates. In effect, this would give another, redder red-orange, a yellower yellow-orange, and so on. In theory, you would assume that orange is a perfect middling mixture between red and yellow, red-orange the mid-point between red and orange, the redder red-orange another middling mixture between the two colours directly adjacent.

PAINT COLORS AND THE COLOR WHEEL

The colour wheel has often been taken as a guide to colour mixing, but if you try to create your own wheel, you find immediate practical problems. There are no such colours as "primary" red, yellow or blue, so you have to choose a named paint colour that seems to you to represent a pure value. You will then find, as you mix them to form the secondaries, that clean mixtures are hard to obtain. Most commonly, you will get a fairly acceptable, or in some cases rather dull orange and green, but the purple will appear brown.

As you have seen from the colour mixing exercises in the previous chapter, paint colours generally have a slight bias towards another colour and pigments do not all have the same tinting strength. In a 50:50 mixture of cadmium red and cadmium yellow, for example, the

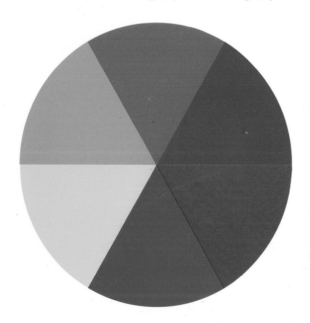

▲ The standard six-colour division of the wheel shows only the three primary colours – red, yellow, blue – and the three secondaries – orange, green, purple.

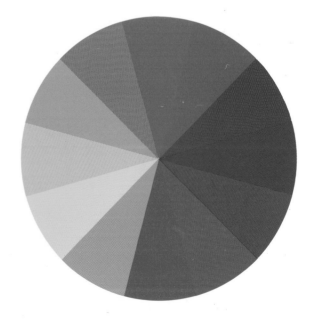

▲ When the wheel is subdivided into twelve sections, you can see the intermediary hues linking the primaries and secondaries, such as blue-purple or yellow-green.

red predominates and you obtain a red-orange. You only acquire this kind of knowledge through experience of your paints, but you can learn to predict what kind of mixture you will obtain by considering the character of individual paint colours, and in this respect the colour wheel is helpful. You can see, for example, that

cadmium red tends towards the red-orange section of the wheel, whereas alizarin crimson is slightly blue and relates to the red-purple section.

Once you begin to look at colours in that way, you can also make use of their relationships as defined by their position on the colour wheel. Colour blocks running in sequence around the wheel form direct links from one to another – these are related, or analogous colours (see page 60). Colours that lie exactly or almost opposite each other on the wheel are distinctly unlike – these crosswise relationships are called complementary (see page 66). Those properties have implications for the ways you juxtapose or oppose particular colours in your painting.

▼ A colour wheel created with named tube colours shows that paint pigments do not necessarily correspond exactly to theoretical colours. However, you can define cerulean blue, for example, as green-blue,

while ultramarine is a purplish or red-blue. Similarly, sap green is a yellow-green whereas viridian is blue-green. This helps you to see their relationships and estimate the effects of colour mixes.

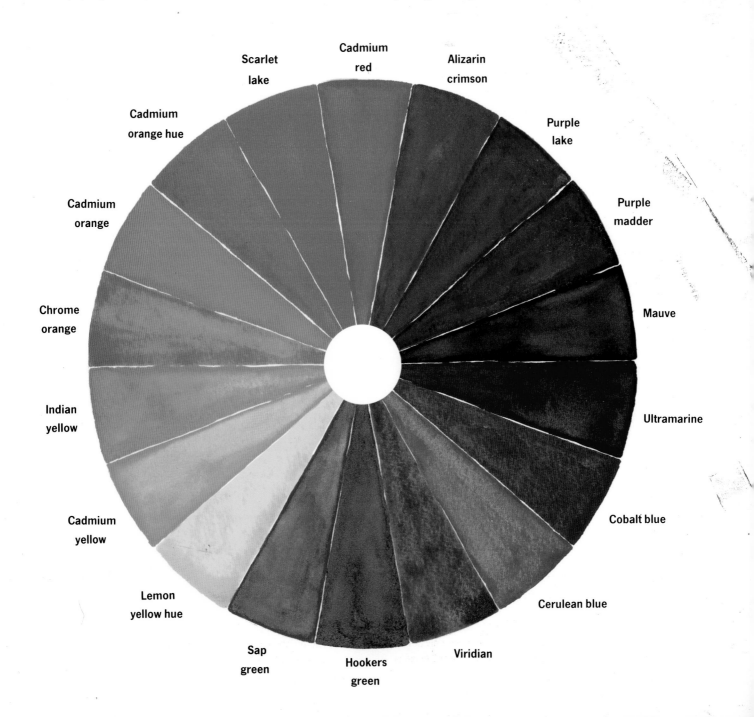

HUE AND TONE

When you lay out a range of colours on your palette you can identify the ways in which they are distinct from each other, both as different colours — red as opposed to blue, say — and, in many cases, that one is lighter or darker than the other. In this way, you are immediately dealing with hue and tone, the fundamental properties of colours.

T he basic form of the colour wheel, as shown on page 54, theoretically consists only of pure hues, and their descriptions on the wheel do not exactly correspond to the names of paint colours or to the names we use to describe the colours of materials and objects. Magenta and turquoise, for example, do not appear as such on the colour wheel; but they correspond to red-purple and blue-green, which do appear.

Tone refers to the lightness and darkness of colours and it relates to hues in two ways. A hue has inherent tone: yellow is a naturally light-toned colour; purple is dark; orange, red, blue and green typically fall within the range of middle tones. Tones can also be seen as the range of light/dark values that a particular hue can take on, for instance if you mixed blue with variable amounts of white or black you will make a run of blue

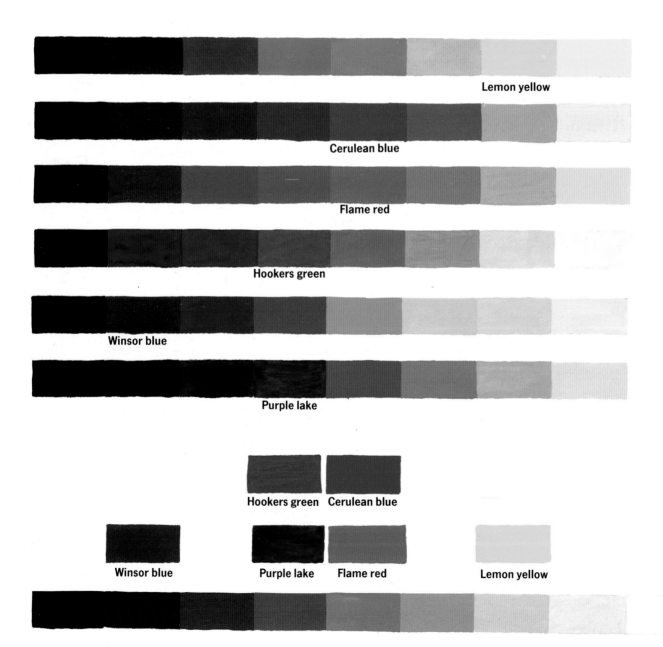

Lemon yellow

Cerulean blue

Flame red

Hookers green

Winsor blue

Purple lake

Hookers green Cerulean blue

Winsor blue Purple lake Flame red Lemon yellow

tones from dark to light. This tonal range does not feature at all on a basic six-colour or twelve-colour wheel.

COLOR INTENSITY

The third basic property of colours is described by the terms chroma, saturation or intensity. All these words mean the same thing, and refer to a colour's strength and brilliance, that is, its degree of colourfulness. Mixing colours reduces their intensity; a mixed colour rarely appears as intense as either of its components. Intensity is also devalued by mixing with the purely neutral "colours", black, white and grey. In practical terms, you see this instantly when you mix black with yellow, which turns it into an olivey green, or with

brilliant red, when red-brown is the result.

In this context, the word intensity is used somewhat differently from the way we might apply it to our own sensations of colour. You can perceive a vivid pink or pale blue as being very intense in the way it works within a painting in relation to other colours, but technically the hue is reduced in saturation. This is one of the more difficult aspects of colour theory to grasp as a principle, but in practice it doesn't really matter; you can make judgements by your visual appreciation of a colour's relative intensity and your commonsense. You know, for example, that when you mix grey into a bright hue, the colour is devalued.

The stepped bands of colour, left, show equivalent primary and secondary hues selected from tube colours in a basic tonal range made by mixing the colour with black or white. The natural tone of the colour means that the pure hue appears at a different position on the scale in each case.

Matched to the grey-scale, below left, you can see how the colours correspond to dark, medium and light tones. A useful way of estimating tones in your painting is to paint a grey-scale on a palette knife and hold it up to your subject (below).

Matching tones ●——————●

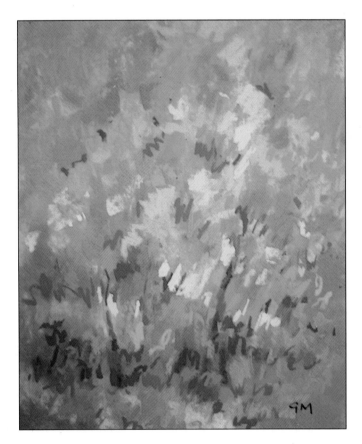

▲ **AUTUMN GLOW**
Geoff Marsters • Pastel
This very direct, joyous use of colour makes the most of pure hues, but there are also delicate variations both in the character of individual hues and the tonal values of the colours. Pastel provides instant, vivid colour impact, but also a rich complexity of descriptive marks.

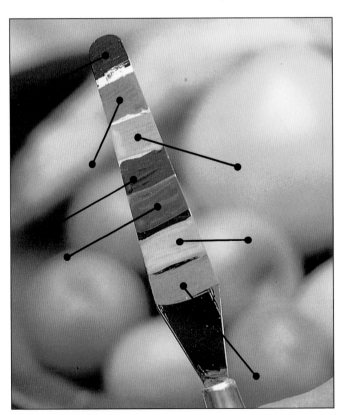

Mixing primary colors

To test the principle that you can mix a range of colours from primary hues – red, yellow and blue – two artists start with a different set of acrylic "primaries". Elisabeth Harden uses acrylic paint in crimson, ultramarine and lemon yellow. Opposite, Judy Martin works with cadmium red, cadmium yellow and cobalt blue acrylic.

1 & 2 Lemon yellow and ultramarine provide a good, sharp green for the apple, but the oranges mixed from lemon yellow and crimson are soft and lack intensity. Crimson and ultramarine form rich shades of red-purple and blue-purple for the aubergine, and are also used thinly for shadows. The lemon yellow has to be tinted with red to achieve the banana colour.

3 With all the local colours in place, the artist works on the mixed colours and tonal variations that enhance the colour interactions. She has put a stronger red-orange on the shaded parts of the oranges so they react more strongly against the apple greens. The warm browns representing ripe patches on the banana skin and the grape stems are mixed from all three primaries, with more red and yellow than blue. The ultramarine content is increased to achieve the darker shading. White highlights have been made by leaving bare paper to show through the colours.

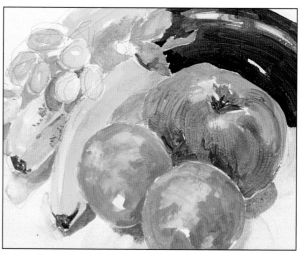

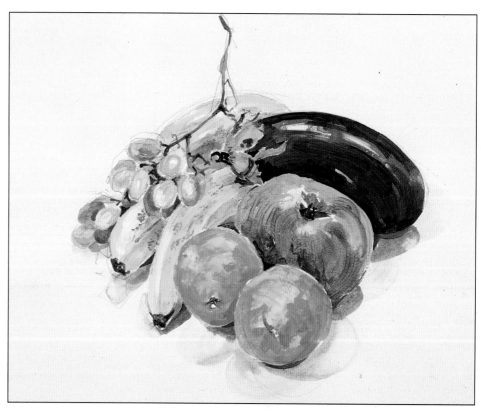

95 485

1 & 2 Cadmium red and cadmium yellow are both warm colours that mix strong, "hot" oranges. By comparison, the apple green mixed from cobalt blue and cadmium yellow is relatively dull, because cobalt is cool and neutralizes the yellow. Similarly, the combination of cobalt and cadmium red is muted – the purple mixed for the aubergine is brownish, but the colour is useful for the grape stems and patches on the bananas. The banana yellow is almost pure cadmium yellow, just tinged with red.

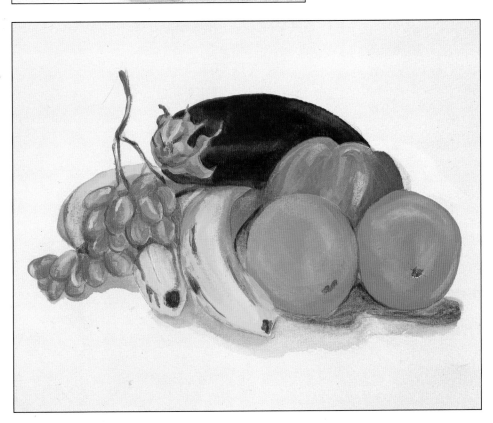

3 Even by varying the proportions in the mix, it is impossible to produce a "true" purple from cadmium red and cobalt blue. The artist uses a contrast of brown-red and blue-brown to suggest the sheen on the aubergine. The greens remain rather dull, which suits the natural colours of the grapes but is less successful for the apple. Intensifying the red-oranges in the foreground helps to "lift" the greens, and the apple green is given more yellow to brighten it. Because the initial colours were applied solidly with opaque paint, the artist has to introduce white to overlay highlights and pale tones.

RELATED COLORS

Using the colour wheel, you can trace direct relationships between colours and work out how these might correspond to the tube colours and mixes on your palette. There is a basic harmony between related colours due to a shared component.

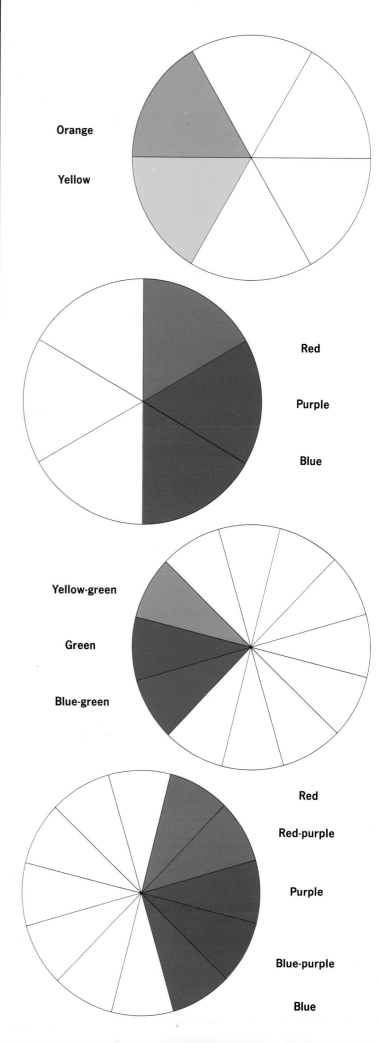

Orange

Yellow

Red

Purple

Blue

Yellow-green

Green

Blue-green

Red

Red-purple

Purple

Blue-purple

Blue

C olours adjacent to one another on the wheel in any given section form a related sequence. The closest relationships are between a primary colour and the secondary which contains that primary, through the intermediary hue (or hues) created by mixing the two – such as blue, blue-green, green. Another kind of related sequence occurs between a primary or secondary and the intermediaries on either side – blue-purple, blue, blue-green; or blue-green, green, yellow-green.

The wheel also demonstrates direct links between primaries – such as in the simple sequence red, purple, blue; or the more subtly extended range through red, red-purple, purple, blue-purple, blue.

When you employ a scheme of related colours in a painting, it tends to produce a harmonious effect. Although any pair of primaries makes quite a strong contrast because all the three primaries are unlike, once you add the secondary and intermediary links, the contrast between the primaries is softened. The harmony of a primary or secondary and the intermediary colours immediately adjacent is more obvious, since all contain the same hue in varying proportion and intensity.

The underlying harmony survives variations of hue and tone provided the colour scheme is broadly integrated. If you select a related colour sequence but isolate individual components in different areas of the painting, you may be breaking some of the links so that the different character of the unlike colours becomes more apparent. But it needs only touches of one colour in another or a subtle distribution of colour accents to form the connections.

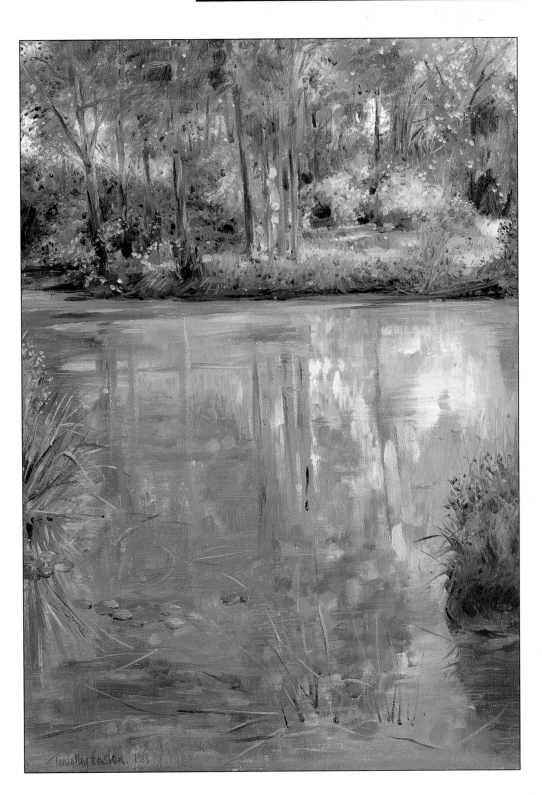

◀ On the six-colour wheel, related colours are one primary and the secondary colour of which it is a component, such as yellow and orange.

◀ The secondary hues link the unrelated primaries. The red, purple, blue sequence makes a colour harmony.

◀ Secondary and adjacent intermediate hues form, in effect, shades of one colour, as with green linking yellow-green and blue-green.

◀ A more subtle and complex sequence is obtained by going from one primary to the next through all the intermediate and secondary hues.

▲ **THE FISH POOL**
Timothy Easton • Oil
Landscapes almost invariably have a natural harmony, which can often be compared to a sequence of related colours. However, the colour nuances in nature are subtle and unpredictable. In this painting the greens are primarily shades of yellow-green, which gives them some contrast with the cold, pale blue, but there is also a unity of tone which anchors the colours in the foreground.

Color harmony

A scale of related colours can be relatively narrow – say, blue and purple only – or it can pass through three adjacent segments on the colour wheel. In this flower painting by Elisabeth Harden the blues are offset by greens on one side and blue-purples on the other. Your approach to colour mixing will depend on the range of your paint stock. Here the artist selects watercolours in several key hues; this enables her to achieve very subtle variations. Alternatively, you could base your palette on two or three blues, and depend on yellows and crimson or rose for mixing the related colours.

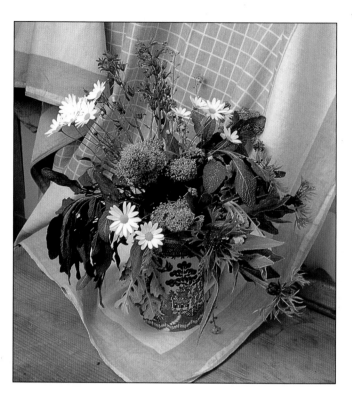

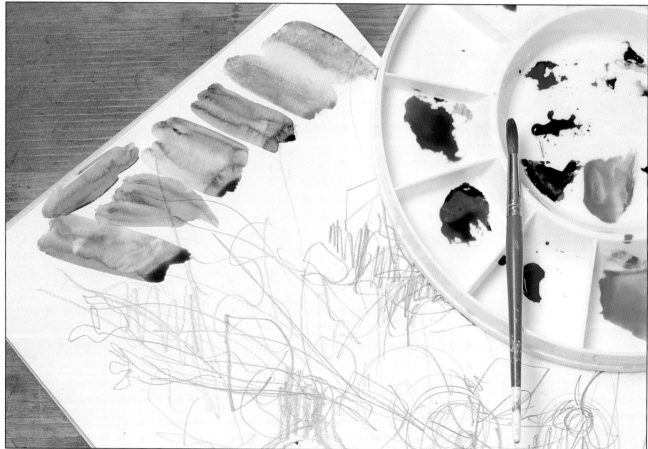

Selecting the palette

Building up a watercolour can be a delicate operation, and the artist takes time to study the subject before starting work on the full painting. She makes a rough pencil sketch of the composition (above left) and tests the colours she intends to use. Her colour range is small but includes different hues from each of her three main colour families – ultramarine and cerulean blue; sap green, olive green and Prussian green; alizarin violet and glowing violet.

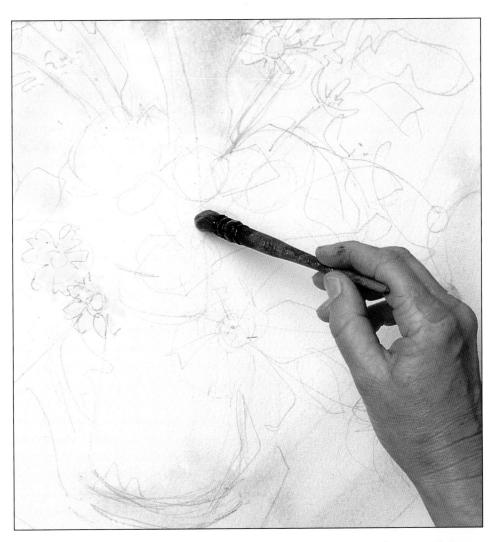

1 The artist begins with a light pencil sketch mapping the main elements of the composition. To "reserve" clean paper in the areas that are to remain white, she applies masking fluid before starting the colour work (the dried masking fluid appears yellow in these pictures). This enables her to brush in the colour washes very loosely and freely, beginning with a broad patch of cerulean blue.

2 The softly spiky forms of the deep blue flowerheads are suggested by dampening the paper and drawing a fine brush loaded with ultramarine through the dampness so that the colour spreads irregularly. This wet-into-wet technique can be controlled by confining the initial damping to small areas of the paper.

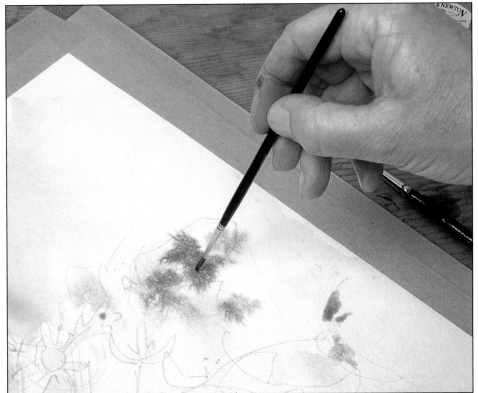

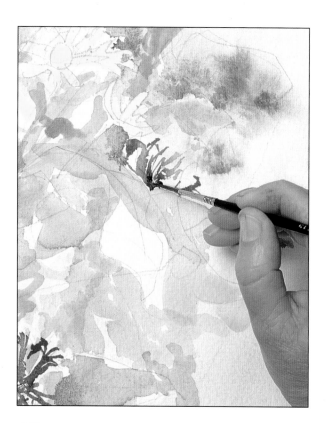

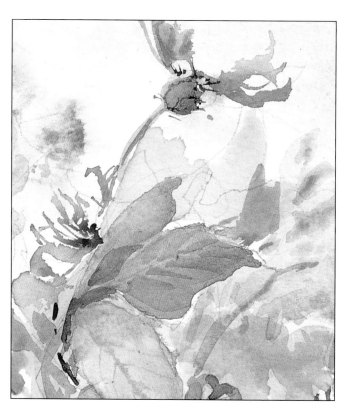

3 All three greens are employed to add patches of colour washes representing the leaf shapes. In places a deeper concentration of colour settles along the edge of the wash as it dries. Then the artist applies more detailed brush drawing of the flowers in alizarin violet.

4 The same techniques are combined to build up the strength of the colours and develop the detail of flowers and leaves. By overlaying colours, the artist achieves some subtle mixes, such as the dull greens modified with light washes of violet and ultramarine.

5 The colours are applied at greater intensity to break up the shapes and add depth to the image. Heavy patches of sap green, used straight and neutralized with violet, provide darker tones that model the edges and undersides of the leaves.

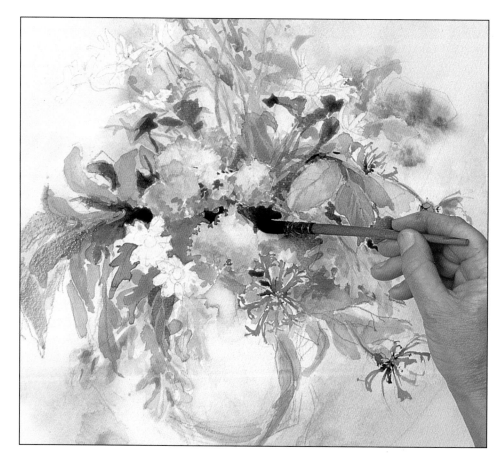

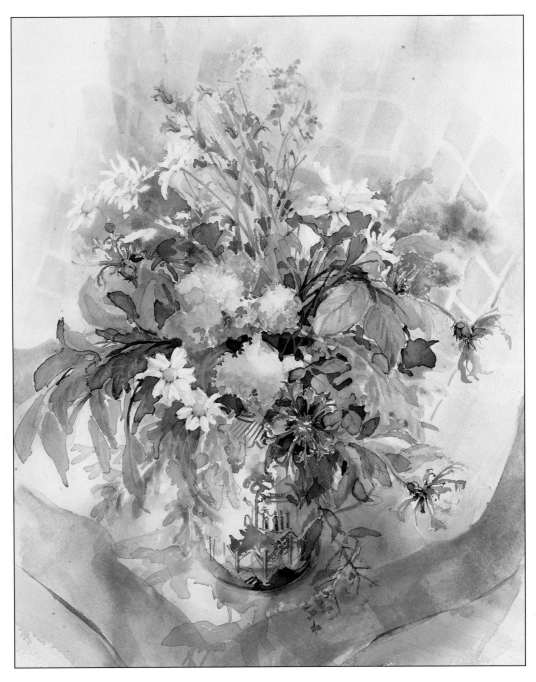

6 Keying the tones from the darker greens, the artist builds up the blues in the same way on the flowers, then adds the detail of the pattern on the jug. The foreground is made much more positive, with the broad band of ultramarine defining the edge of the tablecloth, and the slightly greyed purple cast shadows echoing the irregular flower shapes. With the masking fluid rubbed off, the finishing touch is some light shading on the white petals.

OPPOSITE COLORS

Colours that lie directly opposite one another on the wheel are called complementary colours. There are three main pairs, each consisting of one primary colour and the secondary composed of the other two primaries: red and green, blue and orange, yellow and purple. In a pure form, the secondary contains no trace of the primary colour it is complementary to, so these pairs form particularly striking and vivid contrasts. The complementary relationships continue around the colour wheel so that, for example, yellow-green is complementary to red-purple, blue-purple to yellow-orange.

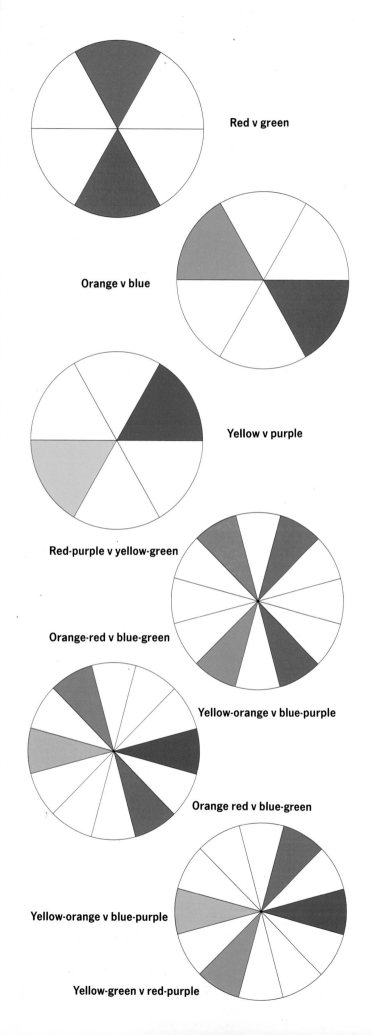

Red v green

Orange v blue

Yellow v purple

Red-purple v yellow-green

Orange-red v blue-green

Yellow-orange v blue-purple

Orange red v blue-green

Yellow-orange v blue-purple

Yellow-green v red-purple

I mmediate juxtaposition of complementaries can produce a very vibrant, even disturbing visual sensation; the opposite hues compete for attention, and at the junction of colour areas you can sometimes see a physical effect, a sort of flickering or vibration.

Powerful colour oppositions in a painting can introduce an effect of drama or discord. But relative values can adjust our perception of the complementary effect – think of the variety of red-green combinations in nature, for example, most of which appear pleasing and harmonious, even if striking in effect. This is partly a matter of taste, but another factor is that natural colours are not always completely unlike: the greens of leaves, for example, are typically tinged with red, so contrast less obviously with red flowers, while pink flowers may appear slightly "blued", thus creating a subtle, half-perceived link between opposites.

SIMULTANEOUS CONTRAST

Colours interact directly in a painting, but the principle of simultaneous contrast draws attention to the sensations of colour that can occur even when a particular colour is not obviously present in physical form. The most extreme example is the "after-image" that you get

◄ The basic opposite, or complementary, colour relationships are each of the three primaries paired with the secondary colour directly opposite on the wheel, left. The corresponding intermediate hues also form subtle complementary variations, below left.

► A very intense sensation of colour contrast comes from complementary colours equally matched in tone and intensity. Various types of red/green and blue/orange combinations fall within the bright mid-toned range. With yellow and purple, there is often a notable tonal difference which makes the colour contrast appear less dramatic.

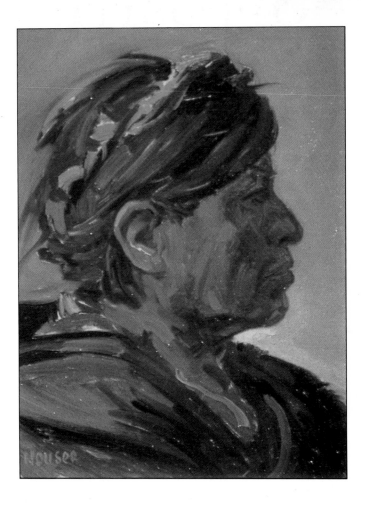

▲ **ZAPOTEC**
John Houser • Oil
This strong portrait shows how complementary contrast can add emphasis even in a muted colour range. The heavy orange background counterpoints the accents of bright blue and both colours seem more intense because of the low-key values applied to the figure.

when you have been looking at a patch of very intense, pure colour. If you stare at the colour, then close your eyes or turn towards a neutral-coloured surface, you see that colour's complementary in a similar shape to the patch you were originally looking at.

This effect is usually quite brief and it comes from your eyes' attempt to compensate for intense exposure to a restricted area of the colour spectrum. It works also when you are looking at adjacent colour areas; you may "read" the contrast as more extreme than it would appear if you were looking at the same colours presented separately. For example, with juxtaposed patches of blue and yellow, the yellow may appear to tend more towards orange, because the complementary effect comes into play. Likewise, it works between hues and neutral colours; a patch of orange on a neutral grey gives the grey a bluish tinge, red makes the grey appear greenish, yellow turns it slightly mauve.

In painting, these effects can be used to help enhance colour values, either boldly or subtly. Adjusting the tone and colour bias of one colour can play up the complementary character of another. You can introduce complementary accents to enliven a broad field of uniform colour or a scheme of closely related colours. You can also use the principle to help differentiate neutralized colour mixes in the buff, beige, grey range (see page 72).

Complementary contrast

Red and green form the strongest of the opposite, or complementary colour pairs. In the mid-toned ranges of these colours there are particularly striking contrasts of hue, which are often exploited in decorative contexts, such as fabric patterning. The red-green partnership is also the one that appears most frequently in natural subjects — flowers, foliage, fruits and vegetables. In this acrylic painting, Judy Martin represents a vivid combination of natural and manufactured colour contrasts.

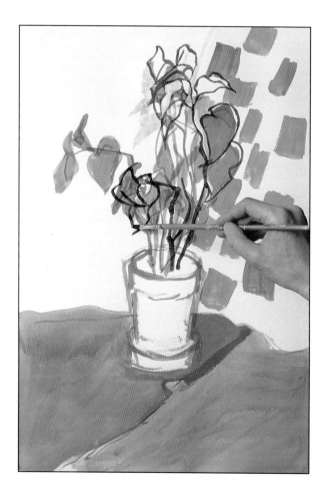

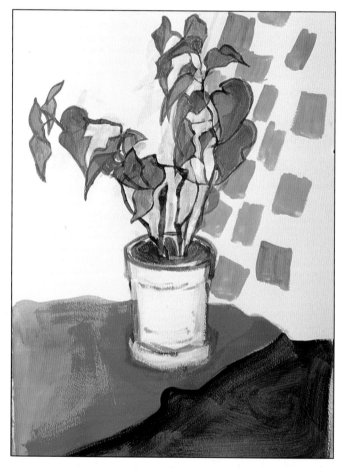

1 When you are approaching a very colourful subject, it can be helpful to start directly using strong colours. Here the artist sketches out the composition in cadmium red, and blocks in broad washes of cadmium red and monestial green. She then corrects the drawing by reworking the lines in green.

2 Obvious errors are blocked out by overpainting with titanium white to simplify the structure of the drawing. Then the basic colours are strengthened, and modifications of tone and hue are introduced. A second layer of monestial green enriches the foreground colour. Leaf shapes are modelled with a brighter yellow-green.

The palette
In the initial stages the colour variations are mixed from a limited palette of cadmium red, monestial green, cadmium yellow, titanium white and permanent violet, the last being used very sparingly to darken the red-browns. The full palette for the demonstration also includes raw umber, leaf green, yellow ochre and cerulean blue.

3 Both the brownish reds and the grey-greens are mixtures of red and green in different proportions, using the principle that complementaries tend to neutralize each other when mixed. White is added for the paler tones, also making the colours fully opaque.

4 As some of the leaf shapes become more firmly modelled, with far more subtle variations of tone and hue, the background colour is strengthened to adjust the balance of the picture. The greater intensity of the juxtaposed colours amplifies the effect of complementary contrast.

5 The rendering of the plant is now quite complex, but the overall impression of bold coloured shapes makes the painting seem a little flat. The artist glazes dark grey shadows on to the white surface behind the leaves and blots the wet colour to soften the tone. The grey is mixed from cadmium red, raw umber and monestial green.

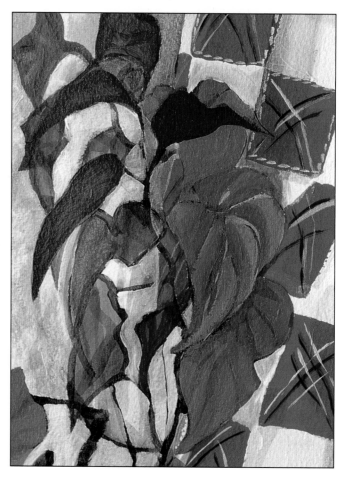

6 The heavier colour on the green leaves creates subtle, interesting surface textures as well as descriptive colour changes. The artist now looks at the interaction between the linear patterning of the leaf veins and the designed pattern on the fabric forming the background. Small details like this vary the colour accenting.

7 The fabric is treated more simply than the organic plant forms. The pattern is simply sketched in local colours, taking account of some distorted and broken shapes formed where the fabric is draped in folds. Grey glazes also help to model this element of the picture.

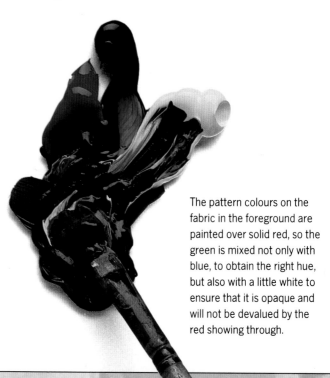

The pattern colours on the fabric in the foreground are painted over solid red, so the green is mixed not only with blue, to obtain the right hue, but also with a little white to ensure that it is opaque and will not be devalued by the red showing through.

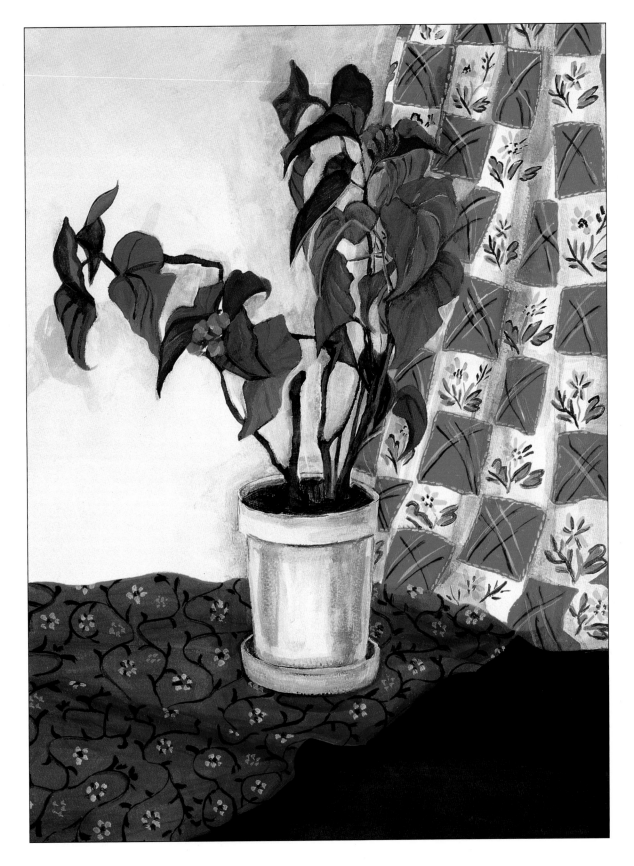

8 Keeping to a relatively limited palette is often a successful
strategy when you are painting with complementaries. Using the
opposite colours to darken each other and create neutral mixes
provides an underlying unity throughout the picture.

NEUTRAL COLORS

There are different degrees of neutrality. Mixed hues can become neutralized, but even greyed and muddied colours are not as purely neutral as the greys formed by black-and-white mixes. Understanding how to manipulate the "colourful" properties of neutrals can help to give your paintings impact.

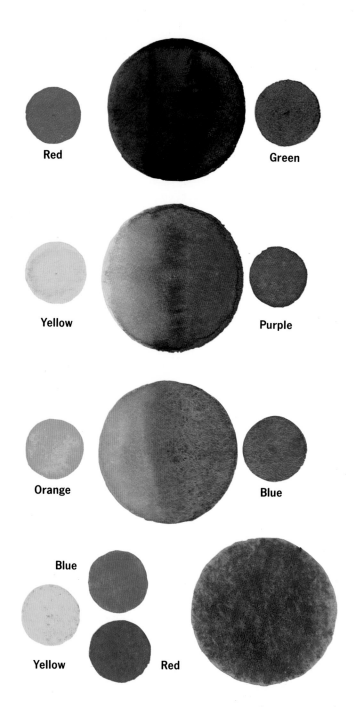

Red Green

Yellow Purple

Orange Blue

Blue

Yellow Red

Black, grey and white have not yet entered the colour spectrum as we have defined it on the colour wheel. They have appeared as an "extra" element in terms of the tonal scale relating to the values of pure hues. The idea of using the colour wheel as the basis of mixing all colours would theoretically include black and grey: black should derive from a mixture of all three primary colours, grey from a mix of any given complementary pair. In practice, however, you have seen that mixing unlike colours tends to produce a range of greenish or brownish "neutrals" rather than the kind of grey produced by a mixture of black and white.

White slips the net entirely in this theoretical framework. Although in the spectrum, based on the colours of light, a combination of all colours produces white, this obviously cannot occur with any mixture of pigments, which have physical substance.

Where black, white and grey have no apparent colour bias, they provide a pure tonal scale and a foil for the interaction of hues. In painting, neutral greys

▲ Mixtures of complementary colours produce neutralized hues. In pigments these are rarely pure grey, but the colours are greyish. Mixes of the three primaries naturally do the same, as they form complementary elements.

▶ Pure hues influence the visual effect of a strictly neutral grey. The grey appears tinged with the complementary hue, so purple turns it yellow-grey, yellow gives the grey a purplish bias.

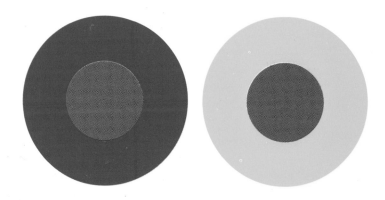

(black and white mixtures), become subject to the principle of simultaneous contrast once integrated with colours in an image, and may take on "colour" by the influence of adjacent hues.

TERTIARY COLORS

A tertiary colour is one that contains primary and secondary components. Although theoretically this should produce a grey, as you have seen from the colour mixing exercises, mixtures of unlike colours create a range of muddy browns and greens, sometimes greyish, sometimes more biased to one component colour. These are inevitably neutralized because the intensity of any component hue is necessarily devalued by the mixing.

The colour influence and tonal value of neutrals depends on the characteristics of the colours used to mix them. They will always be similar to or darker in tone than their ingredients.

▲ **THE RIVER ARNO, FLORENCE**
Stephen Crowther • Oil
By varying the low-key colour mixes the artist finds many enlivening influences in the naturally sombre tenor of an urban landscape. But he shows a confident command of the tonal contrasts and resonant pale tints that give the painting a delicate luminosity.

▲ **SNOW, SOUTHWOODS**
Ronald Jesty • Watercolour
A restrained range of neutrals and the artist's economical but expressive brushwork produce a remarkably rich evocation of the snowy landscape.

Lowering the key

In his oil study of a moonlit interior, James Horton uses the basic principle of mixing unlike colours to obtain a complex range of subtle shades and tints. The stronger reds and yellows are keyed down by adding ultramarine and Payne's grey, the blue and purplish mixtures are "greyed" by adding yellows and browns. He varies the colour temperature of his mixes, playing off warm/cool and complementary contrasts.

As it is clearly impractical to paint in a darkened room, the artist combined detailed observation at night with his direct impression of the room by day to achieve the effect.

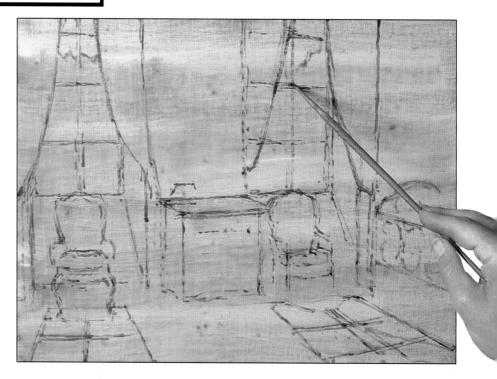

1 As the painting is a low-key study, the artist has prepared a coloured ground rather than beginning on a stark white canvas. After priming, it has been lightly brushed over with thinned paint, of red-purple lightly neutralized with raw umber.

He uses a warm brown mixed with Payne's grey and raw umber to sketch out the composition.

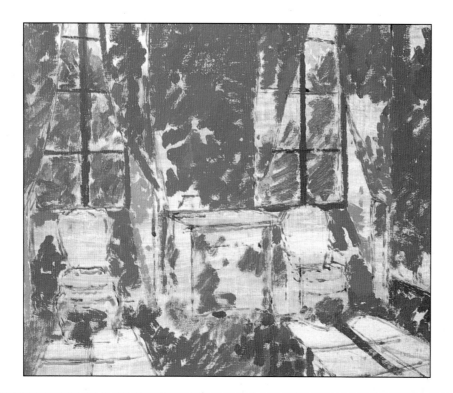

2 He then blocks in an impression of tone and colour, varying the neutral mixes between warm and cool. He creates a basic grey from Payne's grey, raw umber and white, which is modified by adding Indian red or yellow ochre and using ultramarine to "cool" the warmer colours.

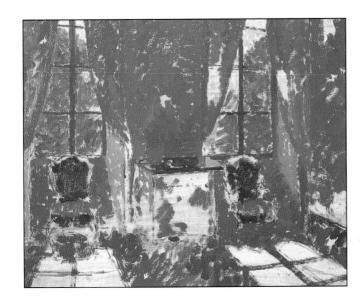

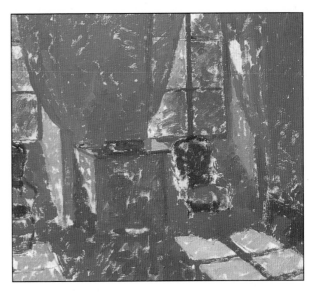

3 Gradually the shapes gain solidity and the overall colour range increases. Small brushstrokes build up an effect of broken colour, so that hues and tones can be subtly varied within each shape. Cool greens and blues (based on cerulean) seen through the window help to balance the image.

4 The aim at this stage is to cover the ground completely, so that the general impression of the picture can be reviewed before any individual section is further developed. The pattern of moonlight on the floor of the room is blocked in with a mixture of raw umber, lemon yellow and white, which creates the highest key for the colour relationships so far.

The palette
At the start of the painting, the artist lays out the colours he wishes to use in sequence. His initial mixtures key the tonal and colour range of the picture.

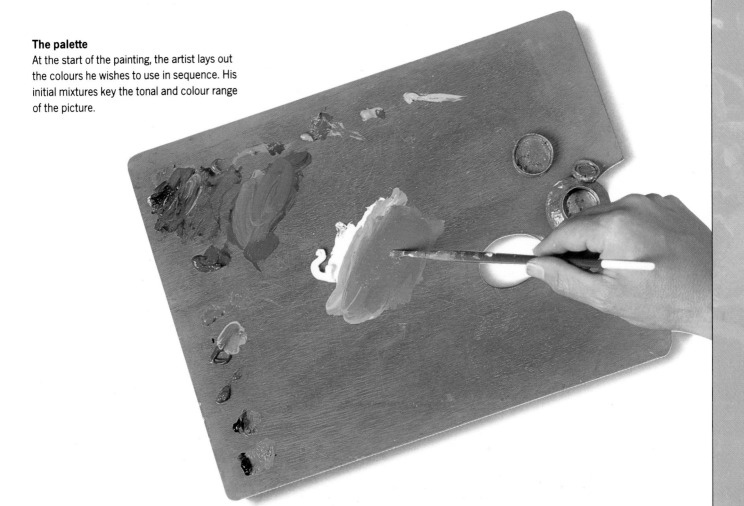

Warm and cool

As the work progresses the palette is gradually covered with a range of neutral mixtures. These initially appear random, but you can see that the warm/cool bias follows the original layout of the tube colours, the coolest shades being mixed from the blues, the warmer ones from the reds, browns and yellows.

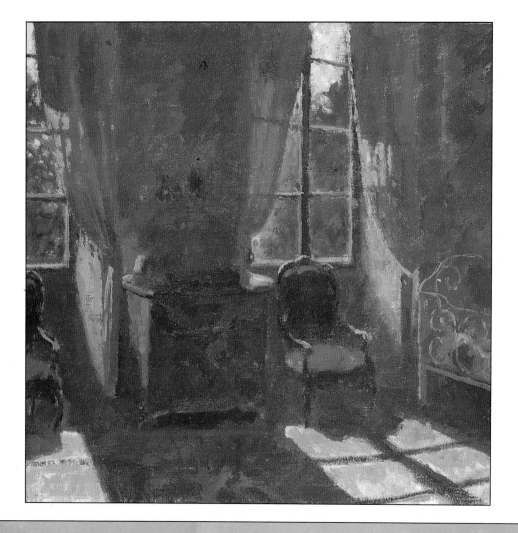

5 Satisfied that the balance of colour and tonal values is working, the artist starts to reinforce the main shapes. He works in a similar sequence to that followed for the earlier stages – notice how the centre wall, curtains and chairs now have a firmer presence. Adding to the low-key range of mid-toned neutrals mainly used in those areas, he applies stronger highlighting which includes bright tints of Indian yellow and a pale greenish-grey containing lemon yellow.

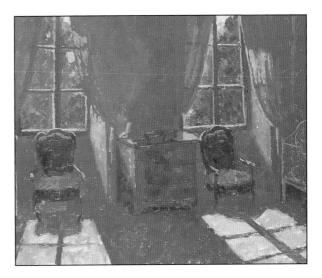

6 Highlighting is added to model the shapes and emphasize the play of moonlight. Cool mauves are applied to show reflected light on the window frame and walls, and a warmer but paler buff tint used to highlight the chair backs and arms. These fine strokes bring out the silhouette of the chair against the light.

7 Finally, he works on developing the density of the low-key colours inside the darkened room and adding descriptive detail, such as the wrought iron bedstead on the right. This is simply indicated with linear strokes echoing the colours of the lit patches on the floor.

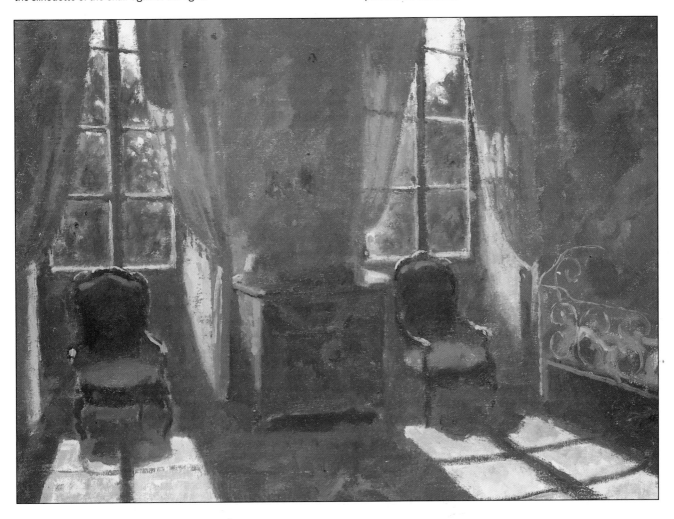

8 The finished painting gives an impression of local colour, particularly the red chairs and yellow curtains, but every hue is neutralized to some degree to convey the low level of illumination.

COLOR
TEMPERATURE

As well as having particular qualities of hue and tone, colours are also categorized as being warm or cool. Broadly, the warm colours are said to be those that fall within the yellow-orange-red sections of the wheel; the cool colours range through the purple-blue-green segments.

The warm colours are generally defined as the bright yellows, oranges and reds. These are colours you would naturally associate with heat. Red-purple is variable, but can appear warm.

T he usefulness of this additional definition is in introducing a further element of contrast that can be put to work within the composition of a painting. It overlaps somewhat with the principle of complementary contrast. Since the overall identity of warm and cool colours splits the wheel roughly in half, you can readily see that some warm-cool oppositions will also be directly complementary colours. But there are more complex and subtle implications.

It is possible to see similar kinds of colour as having different qualities of warmth or coolness. This generally depends on the undertone or colour bias of an individual colour. A crimson red, for example, will appear cooler than an orange-red when the two are juxtaposed. This is because most crimsons have a blue undertone. Similar variations occur in blue: ultramarine, for instance, has a reddish undertone and may appear warm by comparison with the greenish cerulean and phthalocyanine blues. Lemon yellow seems cooler than the warm, sunny cadmium yellow.

In intermediate hues, the dominant primary sets the warm/cool standard; red-purple is warmer than blue-purple. Greens are very difficult to define, although unambiguously categorized as central to the cool range. But we do not all see colours in the same way, and the idea of warm and cool variations is also partially subjective.

Warm colours are often more immediately striking than cool ones in a physical sense – they are said to come forward (advance) from the picture surface, while cool colours appear to recede. This visual sensation of warm-cool contrast can be used to help create space and form in a composition, in association with tonal modelling (see pages 90 and 100).

Greens, blues and blue-purples are typically regarded as cool colours. A true purple is borderline, since it contains equal influences of red and blue.

The fiery hue of orange-red seems obviously warmer than mid-blue, but the degree of contrast is not easy to identify when it is matched with crimson, a blue-tinged red that can appear warm or cool.

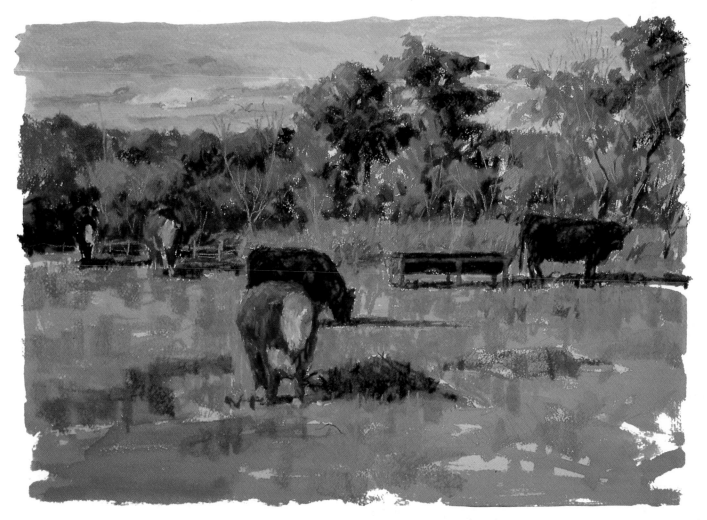

**AMERICAN PRIMAL:
HILLSIDE FARM, OCTOBER
Simie Maryles • Pastel**
Red and gold autumnal tints are applied in the full strength of the pastel colours, and the warm, intense hues sing out from the surface. They are vividly contrasted with high-key cool greens, particularly in the middle-ground of the painting.

Although yellows are defined as warm, lemon yellow has a greenish tinge that can make it seem cool, whether compared to sunshine yellow or to the cool, but deep-toned green.

Purples and blues react variably to each other and their relationship is quite complex. Purple, mauve and ultramarine are all dark-toned, and their density can enhance the warmth of their degrees of red bias.

Warm and cool colors

The interplay of warm and cool colours gives depth to a painting, especially where the subject does not contain a dramatic tonal range. It is particularly easy to exploit this aspect of contrasting temperature with pastel colours and judge their effects much more quickly than with paints. In this rendering of an autumnal landscape, Judy Martin applies a warm acrylic ground for the painting, over which cool colours and variable accents are built up in pastel.

1 The painting surface is a thick, lightly textured watercolour paper. The artist applies glazes of thinned acrylic paint in crimson, cadmium orange, cadmium yellow and burnt sienna, forming the basic contours of the landscape.

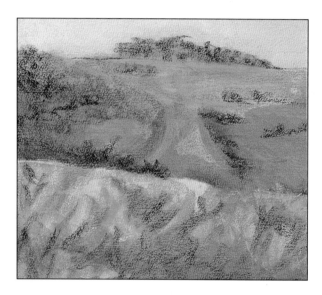

2 The first layers of pastel are also "glazed", using small sections of each pastel stick swept sideways across the paper surface to deposit drifts of grainy colour. Cool blues, mauves and greens are laid over the warm ground.

3 A colder, pale bluish-green is built up more thickly on the grassy areas. The sky is made cooler and more intense with a heavier layer of light cobalt roughly blended with white. The artist begins to draw the detail shapes of trees on the horizon with mid-toned mauve.

4 The contrasts become more pronounced as the cool colours thicken, but tiny glints of warm ground still show through. This gives a sparkle to the picture surface. Notice how the purples are also broken up with overlaid, heavy dashes of pale blue.

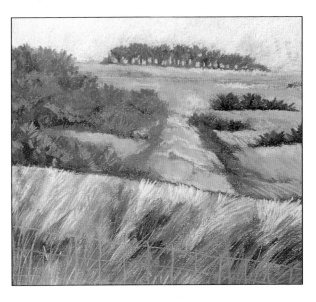

6 The next step is to balance up the remaining broad area of warm colour in the foreground. Slashing strokes of light yellow, light and dark olive greens and two tones of purple develop the grassy texture. This alters the overall impression of the work, so colours in the middle ground are made colder and brighter to enhance the sense of space.

5 The dark-toned bushes are cooled by adding small patches of blue-greens and yellow-greens heightened with purples and neutral grey. Small strokes scribbled with the pastel tips allow the colours to blend optically.

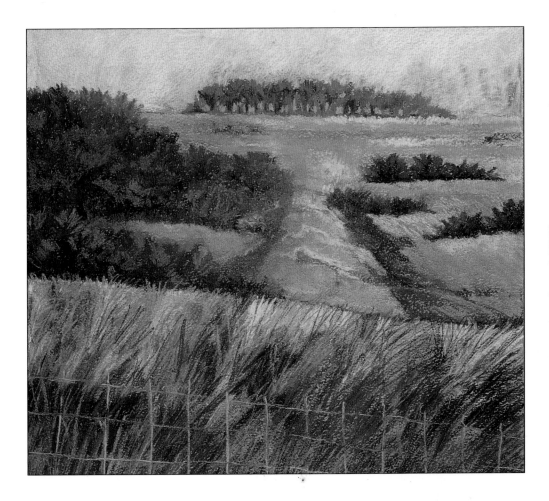

7 One of the exciting features of pastel work is that even quite small colour accents can change the overall effect significantly, and in the final image the colour interactions may be very rich and complex. Here the immediate foreground has been warmed and darkened with sepia and burnt sienna. Against the contrasting fine, pale grey lines of the fencing, this helps to deepen the foreground plane.

Using color

Colour appears to us as one of the given qualities of a subject, a basic attribute like shape and form. But it is obvious from looking at paintings that there are many ways to interpret or manipulate colour effects.

The task of the painter is always to integrate two specific aspects of colour – its descriptive power in relation to the subject, and its physical presence on the canvas or paper. (For the beginner the former – matching or "copying" the colour effects in the subject – is usually the dominant preoccupation. As you become more confident in handling your medium the activity on the working surface becomes increasingly fascinating and the interpretive options more variable and dynamic.)

This section of the book deals with both aspects of using colour through particular visual problems – how to obtain natural-looking descriptive colours and how to use the expressive qualities of colour to develop interesting images and a personal style. It is related throughout to the practical properties of your media, as described in the first section of the book, and to the principles of colour interaction outlined in the second section.

LOCAL COLOR

Of all the visual influences acting on the way we perceive the colours in any subject, local colour is perhaps the element easiest to identify as the reference point from which to begin a colour analysis.

L ocal colour, the actual colour of any object irrespective of lighting conditions or surrounding colours is a basic characteristic that helps to distinguish the components of a subject in simple terms, for example, one object is red, one blue, another green. But more qualification is needed if the description is to be useful, and the words you use to describe a colour more exactly may relate to basic attributes of hue and tone – orange-red, brilliant red, dark red; or they may be associative words – tomato red, brick red.

COLOR MATCHING

When you study a subject in order to paint it, you will almost certainly give attention at first to the arrangement of local colours, because they help you to organize what you are seeing. You can begin a composition by analysing it as individual shapes that have particular colours: then you have to describe those colours carefully to yourself and look for the paint colours that will seem to match them.

Matching colours is a very basic and, as we shall see, sometimes misleading way of beginning a painting, but it can be a valuable exercise if you find it difficult to use colour as boldly and confidently as you would like. Defining shapes in terms of their local colours forces you to simplify what you see and presents you with a foundation range of colour interactions that you can work on methodically.

It rarely happens that a specific paint colour corresponds accurately to the local colour of any element of your subject. Using colour straight from the tube almost invariably means that you are modifying what you see to match your paints, rather than the other way round. You have to grapple with colour mixing right away, even when you approach a subject on such simple terms.

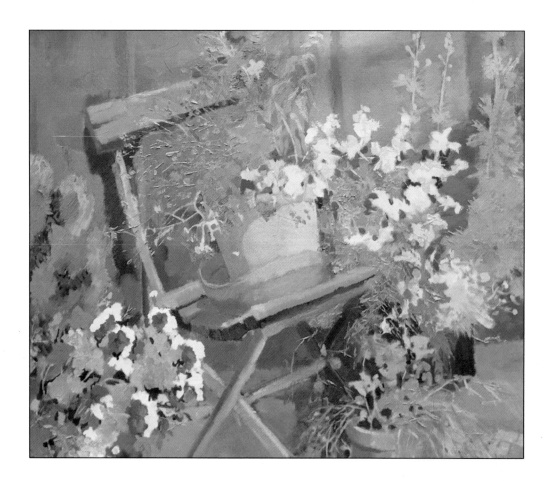

THE GARDEN CHAIR
Olwen Tarrant • Oil
Although this painting contains some sophisticated colour work in the subtle tonal modelling and treatment of shadows, by focusing on the basic shapes of flowers and foliage, the artist gives the local colours an expressive function. The image is made more complex by the boldly handled textural qualities of the paint.

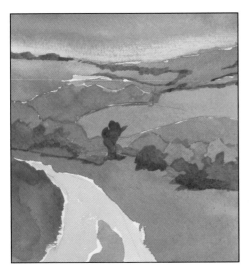

Isolating local colours
Trying to define exact qualities of local colour is a good exercise in sharpening your colour perception. It provides, in effect, a basic plan of your subject and also requires you to give some precision to the component shapes, which can suggest space and form even though the colour variations are simplified.

Light and local color

If you could see an object under pure white light, falling evenly from all directions, you would see the object's local colour almost completely unmodified. But you would have little sense of three-dimensional form and depth, as these elements are normally modelled by their relationship to the angle and intensity of light. These pictures show how local colour becomes gradually less dominant in the simple still life as the quality of the lighting is changed.

You get the strongest impression of local colour under flat, clear lighting that shades forms and surfaces minimally. This picture shows very intensely the individual colour qualities of the objects.

In most settings, indoors or out, the continuity of local colour is disrupted by the way light from a particular source models three-dimensional forms, and by reflected colours, as where the orange on the left reflects brightly on the avocado.

Angled lighting creates a dramatic pattern of shadow that knocks out much of the local colour. Each object is heavily shaded and cast shadows also cut across the shapes, darkening and neutralizing the colours.

THE GIFT OF SPRING
Urania Christy Tarbet • Oil
When a subject contains bright
colour masses like this, the local
colours partially define the
different elements. But colour
relationships are modified by
surface texture, depth, distance
and atmospheric effects.

Remember, though, that the more colours you mix, the more the hues tend to devalue each other. Since it is important to avoid starting off with muddy mixes, it is necessary to analyse the local colours in some detail and look for the most economical mixtures that will represent them. Ideally, if you are looking at a red object, you will be able to mix its hue from two reds, or one red and one other colour. Thus if what you are looking at is an orange-red, you might begin with vermilion or cadmium red, modified with an orange or yellow. If the local colour is a blue-red, you should work from alizarin crimson or rose madder, perhaps modified with violet or blue. If it seems to be a really true, dense, clean red, you might want a mixture between two reds of different character, such as

cadmium red and alizarin crimson. If it is dark, you must decide whether it should be darkened with green or black, which makes the red brownish, or with violet or blue, which darkens it to a purplish red.

You can make this kind of analysis with any colour in the spectrum, using the colour wheel and paint swatches to help you identify and match the colours you see and the colours you paint with. If your local colours are less well-defined – browns, greys and neutrals – you need to look for colour influences: green-brown or red-brown; warm (pink) grey or cool (blue) grey. Take time to study the colour carefully before you start to mix, because if your initial mixture is badly off-key, you will only worsen the problem by trying to add more modifying colours.

COLOR MODIFICATIONS

Local colour is a vital factor in representational painting, but there are two reasons why approaching it too literally can throw you off course. Firstly, the area of an object that actually appears as its local colour may be only a small proportion of its whole surface area: highlights, shadows and reflected colours alter the balance of hue and tone, and can overlay the local colour with completely different, even opposite, qualities of hue and tone.

Reflected colours are most disruptive to local colour on shiny and highly reflective surfaces, but even a dull, matt-surfaced object can be picking up other subtle colour influences from its surroundings. Occasionally when you describe something to yourself by its local colour you can begin on completely the wrong foot, especially with pale colours, which are naturally reflective even when matt. A white wall may display no pure white at all, depending on the light source and the quality of the light that is falling on it.

The second factor that interferes with a simple analysis of local colours is the way colours interact, both in the subject and in your painting. For example, what appears to be a bluish-red will appear more "blued" if it is next to orange or yellow – because of complementary contrasts (see page 66) – but its blue tinge may disappear completely if that same red is placed next to a clear, strong blue. Further, because you are translating what you see into paint colours, the interactions within the subject are not necessarily correctly represented by a sequence of "matched" colours in your painting – the painted areas have their own interactions which derive from the physical colours and textures of your paints. All these more complex influences on creating an increasingly realistic impression in your paintings are further explored in the following pages.

PRICKLY PEARS
Suzie Balazs • Pastel
The attractive colours of the prickly pear separate and define the basic shapes, which are then reunified by the surface details of texture and reflected colour. These form visual links that enhance the circular pattern of the still life. A view from directly above helps to organize the composition in an orderly way.

ANALYSIS

COLOR
AND
COMPOSITION

Because local colour is a realistic, descriptive feature of scenes or objects, one of its functions in painting is helping to identify different elements of the subject. In a portrait, for example, hair, skin and clothing all have their own colours, which contribute to structuring the figure.

Since most naturalistic renderings are concerned with identifying a pattern of light and shadow that creates form — or perhaps with the mood and atmosphere of the subject

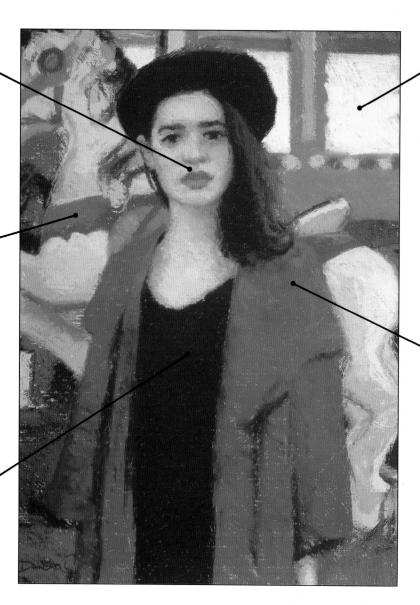

The model's vivid red lips are a small but very important aspect of the painting's colour scheme.

Relatively flat colour areas in the background give unity to the shapes.

This vibrant, cold blue recedes from the hot colours used on the figure, reinforcing spatial organization.

The local colour of the coat is the dominant crimson, or blue-red. Discreet highlighting in orange-red creates sufficient contrast to suggest form.

The solid blacks of the model's hat and sweater form an emphatic central column through the picture, linked by the dark shadow of the hair framing the light tones of the face.

KATHARYN AND THE CAROUSEL
Doug Dawson • Pastel
Minimal modelling gives the local colours in this portrait a strong, dynamic presence. An unusual aspect is the equal intensity of tone and colour in foreground and background. As the figure forms such a powerful shape and graphic colour combination, there is no need to subdue background colours to maintain the sense of space.

– it is unusual to see a painting in which unmodified local colours predominate. The degree of modification, however, varies greatly. In some pictures, the local colours are clear and striking, in others, they are almost obliterated by the influences of tonal modelling and reflected colour.

Strong local colours enhance the organization of the painting, especially when applied to strong shapes. They can help to focus parts of the subject, divide foreground from background, and create vivid colour accents linking different areas of the picture.

Fresh, bright yellows set against neutral grey pull the silhouette of the still life forward from the background.

The intense, translucent red of the currants is conveyed with clever use of broken colour across a range of light to dark tones and orange to crimson hues.

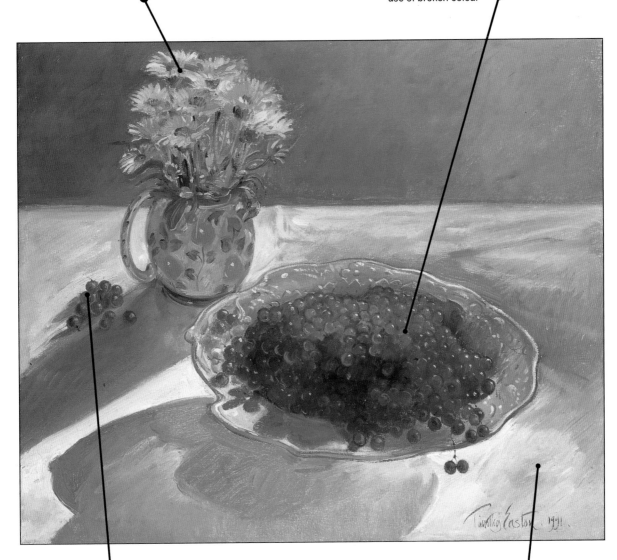

The stray handful of currants forms a colour link with the dominant central shape of the fruits on the plate.

REDCURRANTS AND MARIGOLDS
Timothy Easton • Oil
The artist obviously has a deep fascination with the pattern of light and shade, which floods the white tablecloth with contrasting warm and cool colours. But the vibrant local colours of the flowers and fruit give weight and visual focus to the picture and are positioned in a way that balances the composition vertically and horizontally.

We can read the local colour of the tablecloth as white, although it is described with subtle yellow/mauve contrasts and does not feature pure white paint.

LIGHT AND SHADOW

Variations of tone model form, create space and contribute mood and atmosphere in painting. The pattern of light and shadow explains where the light is coming from and how strong it is; it modifies the effects of local colour and imposes many active and exciting variations on the basic elements of shape and colour in a subject.

I n your painting, these may appear as strong contrasts of hue and tone that create depth and drama, or gentle tonal gradations that model subtle planes and curves or convey the great distances of open landscape. Or you may choose a high-key interpretation of a subject, emphasizing the quality of light by using light tones, or create a harmonious effect by a restricted tonal range that works on related values and eliminates extreme contrasts.

Keep in mind that tone functions two ways in relation to colour. It can be the equivalent of a monochromatic scale on which individual colours can be given a range of tonal variation from light to dark – as if mixed with varying degrees of white or black. Or it can be a natural inclination of certain types of hues, or of specific paint colours, as where yellows are naturally light colours; reds generally middle-toned; violets and purples typically dark.

TONAL MODELING

Modelling is the important means by which painters impart a quality of three-dimensional realism into two-dimensional images. A sculptor builds up clay or plaster to develop three-dimensional form, while the painter uses the tonal range of the palette to model an impression of planes and curves, recesses and hollows, solid forms and the spaces between them. This approach is familiar from drawing, where the greys and blacks applied with a pencil or stick of charcoal must stand for all colours and tones, the white of the paper providing

◀ Tones and colours

It can be difficult to isolate the tonal pattern of a subject by eye and find a logic for applying colours equivalent to the tones. Try making a strict monochrome study (above left), as though reducing the image to a black-and-white photograph. This provides a guiding plan for a second painting in which you can translate tones as pure colour (below left). Working with an extreme, non-representational colour scheme like this may help you to take a bolder approach to interpreting "real" colour values.

BY THE POTTING SHED
John Martin • Oil
The quality of light in this painting creates both form and atmosphere. Interestingly, the degrees of tonal contrast are relatively low key, but the artist has employed a careful juxtaposition of warm and cool colours to assist the effect. The direction and emphasis of brushstrokes also help to differentiate shapes and textures.

high points of illumination. You can use a corresponding "grey-scale" approach when working with colours, or you can make use of the interactions of variable hues and neutral colours to create space and form.

If you go the first route, you may be tempted first to identify the local colours of the subject, then use those colours as your basic palette and create modelling simply by lightening or darkening them. But to do this simply by mixing white or black with your paint colours invites a dull result, as both these neutrals tend to devalue the effect of pure hues.

The traditional oil-painting method widely used until the 19th century avoided this pitfall by establishing the tonal range of a painting in monochrome before introducing local colour. The composition was devel-

oped to a high degree in a colour-neutral tonal range, concentrating on placing the light, mid-toned and dark values accurately and achieving a satisfactory balance. Then the colours were "floated" over the basic structure – the underpainting – in the form of transparent glazes. Detail could be adjusted by adding touches of opaque colour in the final stages, including dazzlingly pure white highlights.

With modern painting techniques, it is customary to develop the relationships of hue and tone – or of local colour and modelling of light and shadow – in a more direct and integrated manner. This typically involves blended colour gradations and techniques for creating areas of broken colour – in which the colours are not physically blended but are applied in ways that

BRIGHTON SHOP FRONT
David Napp • Watercolour
Pure hues can very actively
suggest an effect of tonal
modelling. The use of yellow
lights and purple shadows
introduces both warm/cool and
complementary contrasts that
contribute depth and form.

These create a unified basic
framework for the brilliant
colour accents in strong primary
and secondary colours.

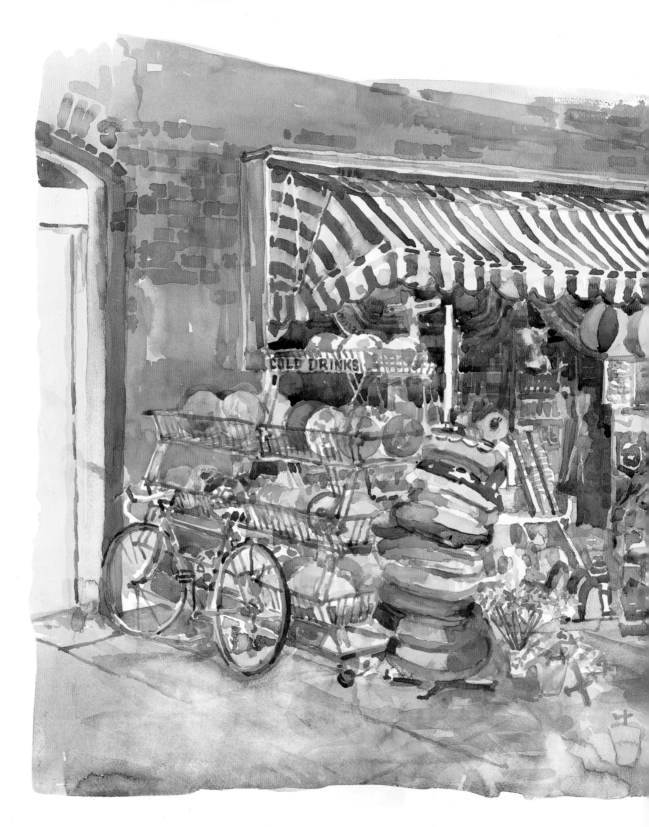

produce an effect of variable colours and tones.

In either case, you should be seeking to avoid the deadening effect that can occur by lightening or darkening colours too simplistically. If the local colour of an object is, say, a mid-toned green, you can shade it more colourfully by adding a darker green or a deep, rich blue than by devaluing its intensity with black. Similarly, you might shade a brilliant red into a maroon red, red-brown (such as burnt sienna) or red-purple. You can also create a neutral mid-tone or dark tone by mixing in the complementary, or opposite colour (see page 66); a green mixed with red produces a brownish-red, and vice versa.

To lighten a colour it is almost always necessary to add white, unless you are working with transparent glazes or washes, when you can simply dilute the colour to different degrees and let the white of the paper contribute to the brightness of the tint. However, white paint which is dense and opaque can dull a pure hue, or bring out a slightly different colour bias – producing a subtle mauve-pink rather than a clear rose pink when mixed with a crimson or madder red, for example. It may be necessary to key the tone more highly than you expect – to make your colour quite a bit paler than it appears in the subject; or to adjust the hue slightly to achieve greater brilliance or colour impact – adding a touch of lemon yellow to heighten a tint of cadmium yellow or orange-pink, for example.

MODELING WITH COLOR

Oppositions of light and shadow can be created effectively with changes of hue and colour "character", which may or may not correspond directly to a tonal interpretation. For example, the interplay of warm and cool colours helps to model form and describe spatial qualities. This might be developed through a tonal and complementary contrast if, say, highlights were interpreted as light, warm yellows and shadows as deep, cool blue-purples. But a light or mid-toned blue or violet shadow area can also work well against dense, warm colours, even though the relative tonal values are modified. If the paler colour is cool enough to appear to recede from the picture plane it can convey the shadowing of a plane or curve turning away from the viewer.

The key to this approach is to search for useful cues in the subject. Often there actually is a distinct purple or indigo cast to shadows; highlights on extremely shiny objects may be pure white, but on less reflective surfaces they might be clear yellow, or strongly tinged

with pink, orange, blue or mauve. Sometimes the effects of light and shade draw out colour influences that are complementary to the local colours of objects and surfaces; at other times they produce subtle gradations through related hues and tones.

CAST SHADOWS

Cast shadow, the kind of shadow that your figure throws onto the ground on a bright summer's day, is an absence of light; but in painting it need not mean absence of colour. Tonal contrast is usually more emphatic with cast shadows than in the shadowed gradations that model shape and form: cast shadows may be hard-edged shapes that cut right across an otherwise strongly illuminated area.

To deal with these as a positive colour element enlivens a painting, provided you key the tone correctly and avoid a too-strident intensity of hue. However, representing dark tone with colour should not become

a mere painterly trick, and it is not always appropriate. If you want to give your painting a particularly strong graphic impact, there is no darker, more dramatic colour than a clean, heavy black.

THE LIGHT SOURCE

The tonal framework of an image underpins the colour interactions. You may find that a painting is not working because it lacks a strong enough arrangement of tonal values, however carefully you have considered the scheme of colour. This does not necessarily mean employing a very full and detailed tonal range: the entire palette of many highly successful paintings occupies quite a limited section of the tonal scale. But there is a balance to be sought, whether you are employing high-contrast values or subtle mid-tones.

Tonal structure derives directly from the subject in front of you; although you can exaggerate or underplay it to a certain degree there is no point in attempting an

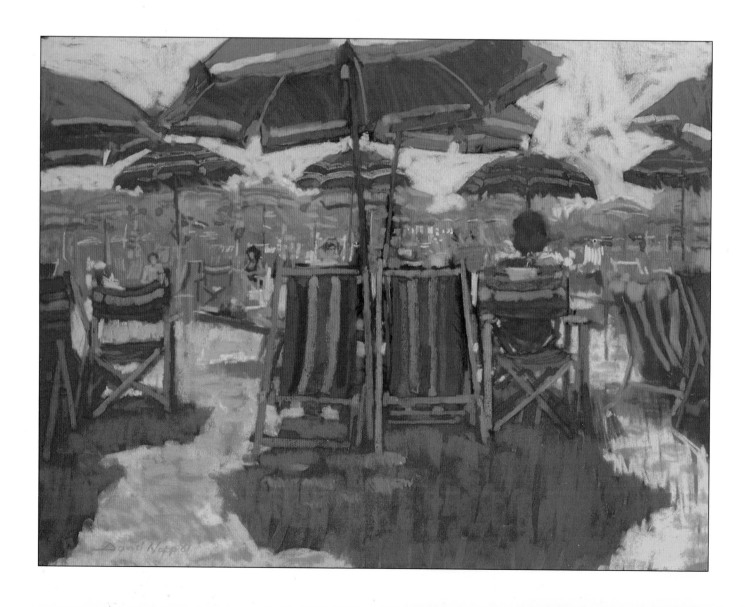

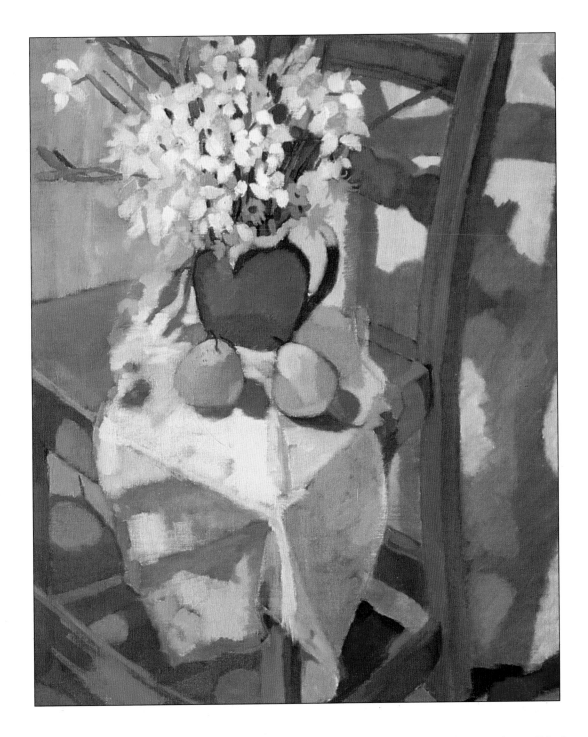

◀ **DECKCHAIRS AND PARASOLS**
David Napp • Pastel
An intense, striking colour range like this needs to be anchored by a balanced sense of composition. The large shapes of the umbrellas and their cast shadows, solidly blocked in with cold blues, greens and purples, give weight to the picture, and hold down the busy pattern of hot colours across the centre. The directness of the pastel medium can help you to avoid subduing your colours unnecessarily.

▲ **THE BLUE SHADOW**
Olwen Tarrant • Oil
A cast shadow can be seen as a negative shape, but here it has attracted the artist's attention to such a degree that she makes it the subject of the painting. Although the blues and blue-purples are relatively light in tone their coolness conveys the shadowing without ambiguity. This element travels right through the painting in the cast shadows of the apples and the modelling of the chair and fabric.

interpretation so different that it requires you to imagine a pattern of light and shade. Directional light, whether indoors or out, produces variable contrasts and a fairly complex arrangement of broken shapes. A flood of even lighting from a central source smooths out some of the tonal modelling in a subject and may also flatten colour variations. Conversely, a small, contained light source dramatically illuminates strong contours while darkening internal shapes and obscuring detail in surrounding elements. Gentle outdoor light, from a weak sun or filtered through the atmospherics of mist or rain, eliminates definite contrasts but creates unexpected, subtle shifts of colour and tone.

You do not always have the means to control the light on your subject, but when you can create the set-up for a still life, portrait or figure painting, it is worth giving as much thought to the direction and intensity of the light as you do to the objects or people you choose as your models and the way you arrange them.

The lighting can make or destroy a particular configuration of shapes or set of colour relationships.

Even when the light is a given factor you can still decide to use it selectively in the picture. In interior scenes, for example, you often have light coming from more than one source – through a window and a door, or from natural light outside and artificial light within. This can create interesting variations of shading and reflected colour, but it can also confuse – the modelling of a solid form, for example, may be less easy to construct if it is lit from different directions. Where you cannot eliminate a second light source, you may wish to play up the highlighting coming from one direction and play down reflected light from the other. You need to be careful, however, about analysing what is influencing the particular effects of the colours and tones you see.

Pay attention also to the colour quality of the light – daylight is typically "cooler" than artificial light, for

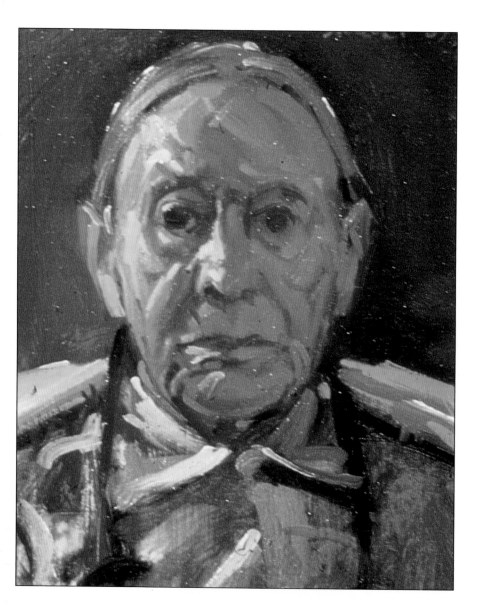

WALSI

John Houser • Oil

Strong sidelighting gives dramatic impact to a portrait, highlighting the modelling of the face on the lit side. The artist has broken up the flesh tints into powerful slashes of colour representing light, medium and dark tones, but the brushstrokes are firm and directed, shaping the planes of the face. Although there is a concentration of intense light, tiny reflected highlights on the opposite side of the head bring out its full contour against the background tones.

A DAY AT KELEEN
John Sprakes • Tempera
The impression of dappled light has great immediacy and charm, but the painting is technically complex. Shapes are full of detail and nuance, formed from layers of loosely brushed colour, scumbling and vigorous hatching. The chairs, for example, reveal a busy network of widely varied blues and purples accented with yellow and white.

instance; early-morning light may be cool (bluish or lemon yellow) and late-afternoon light warm (orange-yellow or pink). Any such distinct colour bias will modify local colours quite dramatically.

CREATING A MOOD

As well as helping to construct the spatial organization and modelling of solid forms in your picture, tone is a powerful ingredient of mood. The chiaroscuro effect, employing dramatic contrasts of light and dark with little in the middle tonal range, has a theatrical flavour, often used to dramatize interiors or figure groups. Confining a pictorial scheme to one end of the tonal scale – very pale, brilliant lights or deep, obscure darks – can have a disturbing element because it is an extreme interpretation – the world is usually more variably shaded. It can simply be descriptive of a particular time and condition, however: an open, outdoor scene under a flood of sunlight, with minimal shadow; or a night-time view when only a few points of light pierce the overall darkness.

A broad spread of mid-tones or evenly balanced tonal distribution typically creates a calmer ambience. In this case, the colour character of the image contributes more to setting the mood. Muted hues, pastel colours and neutrals work towards harmony; strong, intense hues are more dynamic, especially if they include complementary contrasts and discordant combinations of hue and tone.

ANALYSIS

TIME

AND

MOOD

Different times of day have individual qualities of light and colour that help to set the mood of a painting. Among the significant indicators are the colour and tone of the sky, the shape and intensity of cast shadows, and the way local colours are intensified or neutralized by the pattern of light and shadow.

Technically, you might find it easier to capture these particular qualities if you use an opaque

The pale yellow tint of the sky is one of the highest tones in the picture, giving emphasis to the shadowing of the landscape.

The long shadows typical of late afternoon and evening light are painted here with muted, low-key greens rather than heavy dark tones.

The darkest shadow areas are occasionally lit with pale, cool colours, offsetting the warm yellows and browns of the adjacent foliage.

Water reflections repeat the colour and tonal key of the sky, creating a vertical balance through the picture.

SUMMER EVENING
Trevor Chamberlain • Oil
The warm evening light is beautifully conveyed by both the yellowish colour cast of the picture and the orchestration of tones. Shadows are softly coloured, not harshly contrasted against the lit areas, creating a peaceful ambience. The glints of brilliant light haloing the figures and touching the tips of the riverside grasses illustrate the glancing angle of the low evening sun.

Set against the fall of light, the figures are virtually silhouetted, but subtle colour contrasts give just enough modelling to characterize their poses.

medium rather than transparent watercolour; both the paintings shown here are in oils. With a dense medium you can overpaint light colours on dark and rework the balance of colours and tones. It is often necessary to exaggerate contrasts in a very brightly lit scene, for example; but handling a range of muted, middle- to dark-toned shadow colours can also be a challenging task that may involve many gradual modifications on the working surface as the painting develops.

Certain colours reappear in different parts of the picture, forming a visual link that anchors the multi-coloured overall impression.

Flesh tints are subtly neutralized when in shadow, explaining the relationship of the figures to the light source.

Dense, quiet colours spread evenly across the background intensify the active shapes and colours in the foreground.

Purple shadows are set against the sandy colouring of the beach as a clean, direct contrast, with no transitional tones.

VOLLEYBALL
Andrew Macara • Oil
Vivid colour accents, flashes of intense highlighting and hard-edged cast shadows describe the powerful illumination during the middle period of a summer day when the sun is high and strong. The light-dark contrast is interpreted not only through tonal variation but also with the complementary contrast of yellow and purple.

Vigorous strokes of pale colour highlight the figures, giving a clear sense of three-dimensional solidity although the forms are simplified.

Tonal modeling

On objects like these, which have simple shapes and smooth, continuous surfaces, the pattern of light and shadow that models the forms is relatively subtle. There are few very intense highlights or dark shadows, but each surface displays a range of subtle colour nuances in response to the light. James Horton matches the colour values accurately in his attractively bright, small-scale oil study.

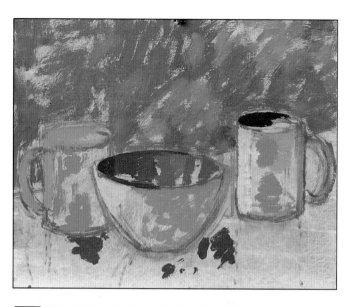

1 The artist uses Indian red to sketch out the composition, then starts to block in two or three values of each local colour. He looks first for the light and mid-tones on the outer surfaces, keys the darker shadows inside and below the objects, and brushes in the general background tones.

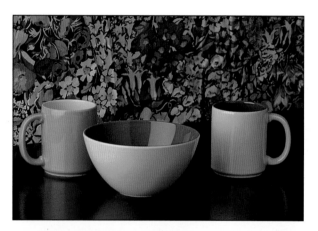

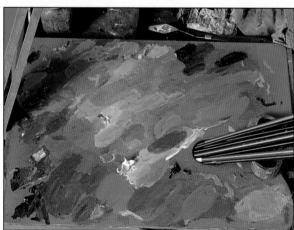

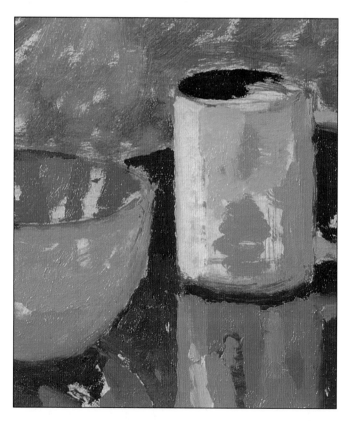

The palette The artist works with a basic palette of selected warm and cool colours that gives a wide enough variation of mixes to enable him to cover the range of most subjects. He includes two blues – ultramarine and cerulean – and two yellows – cadmium and chrome, but no green. The other colours are yellow ochre, chrome orange, raw umber, Venetian red, cadmium red, alizarin crimson, Indian red, Payne's grey and titanium white.

2 As he builds up the modelling more thickly, he introduces subtle modifications of colour and tone. The intensity of the yellows is varied, using cadmium red and chrome orange to warm them, and the bluish Payne's grey as a neutralizer for the deeper tones. The orange mug and its reflection are shadowed with Indian red.

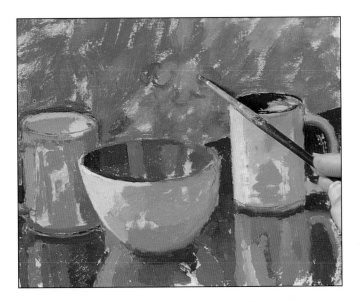

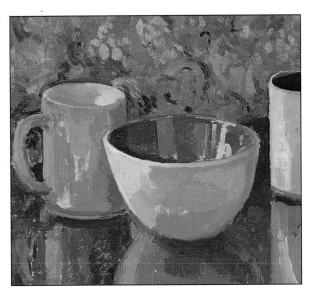

3 The cool blues and blue-purples inside the dish and on the background fabric pattern have a complementary relationship to the oranges and yellows, so these elements are brought up more strongly for contrast before further work is done on the warm hues. At each stage, the artist also touches in the pattern of reflected colours on the shiny, dark tablecloth.

4 As the shapes and patterns gradually fill out in more detail, stronger highlighting is introduced on the china objects and the tabletop. Although the artist uses no pure white, the brilliant, pale yellow, orange and blue highlights intensify the lighting of the still life and emphasize the shapes.

5 Even on the smooth, shiny surfaces the individual brushmarks and patches of colour can be clearly identified, but because the tones and colours are so well integrated the surface modelling is very cohesive. The hard-edged forms, echoed more loosely by their reflections, stand out from the background, which provides some colourful, bright accents although its overall tone is relatively muted.

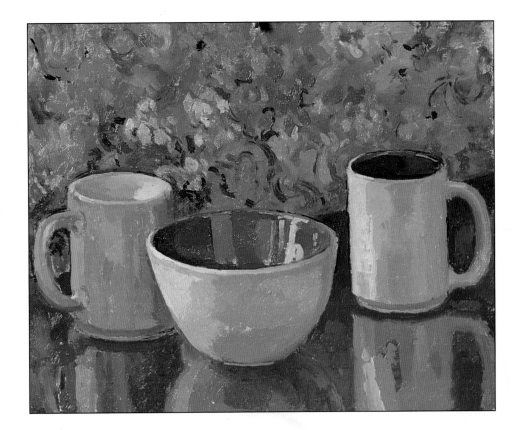

COLOR RANGES

Whether you are primarily attracted to a subject by its colours, or are observing colour as one descriptive element for representing objects, people or places, you need to employ a balanced combination of visual and technical skills. The range of colour variations that you see and select from has to be interpreted according to the range of colours in your palette, their capacities for mixing, and the physical properties of your medium.

T his may seem self-evident, but it is surprising how often we fail to recognize that particular media and colours have inherent limitations, as well as a high degree of versatility. Understanding the properties of your medium helps you to view the subject appropriately from the start, to analyse and select the information that you can interpret effectively.

COLOR THEMES

Most paintings can be seen as falling into one of three broad categories in terms of colour scheme: a general impression of harmony derived from a range of related or similar colours; deliberate contrast formed by exploiting obviously differing colour characteristics, such as complementary or warm/cool contrasts; or a "multicoloured" effect, in which the colour relationships are apparently much more random, due to many variations of local colour in the subject and further modifications created by the pattern of light and shade.

When you select or set up a subject for painting, you may initially be attracted by a harmonious or complementary scheme inherent in the subject, or see the possibility of arranging the components in such a way by choosing particular props and accessories. No scheme has to be exclusive, however. For example, if you are working with related colours, you may wish to include small accents of contrasting colour that will give the picture a lift without disrupting the overall harmony. If you are using complementaries or warm/

VENICE
Ann Whalley ● Watercolour
Architectural subjects often suggest a sombre palette of neutralized colours. Although this is the overall theme of the Venice watercolour, the artist has found attractive, soft contrasts between the browns, dull greens and warm greys. The colours also create a strong tonal scale, unusual in placing the darkest tones in the foreground and lightening towards the background. But that balance in the painting is opposed by the brilliant strip of light reflecting on the water.

cool contrast, you may be spreading the contrasting elements fairly evenly throughout the picture, or you might arrange them in a way that makes one kind of colour dominate a particular area of the picture, with the contrast more broadly stated elsewhere.

Where colour sensations are more complex and varied, you can take one of two approaches. You can deal with them in the broadest possible way by trying to find equivalents for all the colours and tones, or you can approach the subject more selectively, revising the key of the hues and tones in order to organize relationships and oppositions more deliberately.

The selection of paint or pastel colours that you start with directly controls whether you are able to match the subject's given colour range. As explained in the first section of the book, particular red and blue pigments produce brown when mixed, not violet or purple. Particular blues and yellows in combination produce certain types of green. The fundamental character of that mixed colour is not going to change whatever you do with it, so you need to begin with a palette of colours that can provide sufficient variation.

However, you can also manipulate the colour relationships to some extent within the image to enhance or subdue certain effects and interactions. The ways of doing this mainly depend on varying the balance between like and unlike colour characteristics – intense, pure hues versus muted and neutral colours; light against dark tones; complementary contrast; oppositions of warm and cool colour. In addition, you can use the paint texture to help you vary visual effects – contrasting the flatness and density of opaque colours with the luminous and variable surface qualities of transparent colours, using techniques of layering the picture surface and building up complex patterns of broken colour.

It may seem extreme to suggest that you change your medium if you have a recurring problem with obtaining the colour effects you require. But this can be a useful way of breaking a habit of repeated error, or of working your way through an inhibited or unconfident approach to colour. The methods of applying watercolour, say, or soft pastel are naturally different from those you might use for oil or acrylic painting.

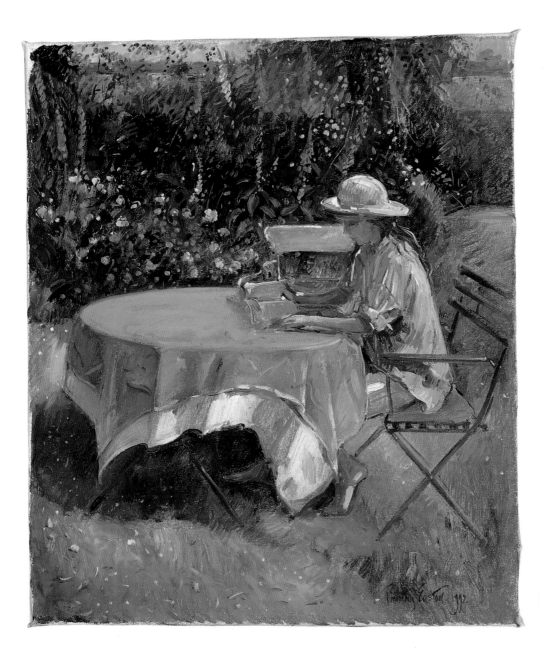

THE SUMMER READ
Timothy Easton ● Oil
The painting's natural setting contributes to a harmonious effect, but the individual colours represent the entire spectrum and form a complex colour harmony. There are direct, linking relationships – yellow to green, green to blue, blue to purple – and also direct opposites. The latter is most obvious in the complementary yellow and purple contrast, but tiny pink and red accents also complement the greens. The balance of tones and intermittent emphasis of pure hues against muted colours create subtle contrasts with no jarring notes.

▶ **LONDON CITYSCAPE**
Pip Carpenter • Watercolour
A crowded townscape presents a complex colour range. Where there is a predominance of neutrals the artist has created "coloured greys" by the interaction of blues, purples, yellows and browns in thinly washed layers and sketchy, broken-colour areas. The active brush-drawing technique enables her to introduce stronger colours discreetly and integrate linear marks with broad shapes, so the surface contains many variations of colour and texture that enliven the rendering.

▲ **A NORFOLK BEACH**
Alan Oliver • Pastel
The artist has made an interesting combination of the low-key earth colours forming the landscape setting and the vivid splashes of high-key colour and tone contributed by the people on the beach. He uses the traditional pastel technique of working on a coloured ground, but the mark-making is vigorous and economical. Forms are minimally suggested with loose side strokes and heavy directional marks, but the painting is highly descriptive and achieves a unique atmospheric feel.

Technical experiment, in either a different medium or the same one, often unexpectedly provides a much easier solution, and having "broken the block" you may be able to go back and solve your original problem as well.

FINDING THE KEY

An interesting aspect of working with colour is that although we all attempt to analyse colours objectively, there are no standards for measuring "correct" interpretation, nor is there any direct means of comparing our own perceptions with someone else's. This is the more true with elements of colour that in themselves can be variable, such as the effects of complementary contrast or the apparent "colour temperature" of a hue. So, while it is immensely useful to take in advice and information, and study the ways other artists use colour, you must ultimately rely on your own judgement.

You don't have to begin a painting with a preconceived plan of approach, but it is helpful to identify the particular problem or challenge that you are facing and develop an idea of what you want to do with it. Are you aiming for a detailed rendering or a broad impression? Have you chosen the subject for specific qualities of light and colour, or are these the tools you must employ to describe shape and form? Are you trying to capture a somewhat abstract quality of mood or atmosphere, and are there basic principles of colour relationships or techniques of applying colour that can help you do so?

Keep in mind that even if you are aiming for a strictly representational painting, it is always an interpretation, not a copy. You need to be selective about using what you see in your subject, and imaginative in your treatment of it – what you put down on canvas or paper is not the thing in itself, but a pictorial equivalent, and this means allowing the painting to develop its own character as you go along.

ANALYSIS

LANDSCAPE
GREENS

The immensely varied range of greens in landscape is one of the features that may make you want to paint a particular subject, but it can be difficult to achieve the colour variations that convey a vivid effect and are also natural-looking. Some tube colours, like viridian and leaf green, are very brilliant but have an artificial quality, while greens mixed from blues and yellows often seem duller than intended.

As light is such an important feature of landscape, you need to handle the tonal range of the colours effectively as well as the changes of

Dark tones in the background contain blues and browns that give weight and depth to the picture.

Translucent washes of yellow-green over dark green suggest sunlight filtering through the trees.

Unpainted paper provides flashes of white highlighting which convey the intensity of the light.

A gentle, pale, flat wash makes the lawn appear bleached by the sunlight.

The brightest leaf colours in the foreground are almost pure yellow, but they are directly related to the darker greens through subtle intermediary shades.

AL FRESCO
Hazel Soan • Watercolour
The gradual build-up of colour necessary in the watercolour technique enables the artist to develop a complex range of greens. The versatility of the palette is enhanced by the delicate textures of the paint and the artist's handling of it; she created hard-edged, clear shapes contrasting with soft fusions of colour to describe form and atmosphere.

hue. This combination of factors can sometimes be accurately represented by mixing variants based on tube greens. But it can be more effective to incorporate other pure hues in the painting – yellow, orange and blue for example – that blend with the actual greens by optical mixing, or in the context appear to function as greens.

A tube colour that appears too brilliant or artificial can be knocked down by adding a touch of its complementary – natural greens often have a hint of red – but this must be managed carefully, as too much red will neutralize the green. You can also be imaginative with the colours you use to darken greens, mixing in "heavy" shades of blue, purple, red or warm brown – ultramarine or Prussian blue, deep violet, alizarin crimson, Indian red or burnt sienna could be useful colours.

In the far distance, the greens are blued and neutralized.

Blue-greens create depth at the centre of the picture, drawing the viewer into the townscape.

Bright mid-toned greens convey sunlight playing on the outer branches of the massed foliage.

Cold blue-purple shadows emphasize the relatively warm qualities of the yellow-greens.

DELL PUIG MARIA
Olwen Tarrant • Oil
The artist achieves the effect of brilliant sunshine by using a predominance of yellow-greens in the foreground. Their brightness matches that of the reflected light in the townscape behind, while in the distance all the colours are muted. The composition is unified by many subtle links and contrasts between warm and cool colour variations.

High-key greens and yellows in the foreground hold their position against the brightly lit middle ground.

DOMINANT COLOR

Where you have a distinctive colour theme in a painting, such as the range of greens found in certain kinds of landscape, there is a virtue in similarity. The family relationship between different hues and tones of one colour creates a natural harmony, and colour provides a unifying factor between variable shapes and forms in the composition.

A llowing one kind of colour to take on a dominant role in a painting can increase the impact of the image. As with landscape, you may find there is a given colour emphasis already in your subject – in interiors, for example, where furnishings and wall-coverings may have been deliberately chosen to coordinate and follow a colour theme, or in groups of people dressed for a particular occasion. Alternatively, you may choose to set up your subject in such a way that it provides the colour links – still lifes of flowers, fruits, vegetables or domestic objects are often organized that way.

It can be a subtle challenge to your skills as a colourist to evaluate the colours' closeness rather than distinguish their differences, which often seems the more obvious task. There is a special satisfaction in bringing off a very delicate variation between closely related colours – the exact degree in which they differ in intensity, tone, and bias toward any other hue. It is also important to keep the identity of your theme colour to the fore – not to mask the impact of a dominant colour – while at the same time handling the modelling and pattern of light and shade in an effective manner.

HARMONY AND COUNTERPOINT

A concentrated mass of one kind of colour can appear over-intense or, paradoxically, rather dull. Generally you can appreciate the essential characteristics of something most clearly when it is compared or contrasted with something else. A range of selected pigments can provide harmony with variety – think of the different resonances of cobalt blue, cerulean, ultramarine and Prussian blue, for example. But sometimes you will need to introduce deliberate contrast to "flavour" the dominant hue. This can be tonal – a brilliant pale colour, even pure white, set against rich mid- or dark-toned colours; a flash of complementary contrast; or an opposing warm/cool element.

The degree to which you have to develop the counterpoint may depend on the exact components of your subject. If you are setting up a still life, you can devise the balance of colour and tone to your own specifications. In landscape or townscape, you may find a

key element in some incidental detail of the subject. In the case of figure groups or portraits, flesh tints tend to separate themselves to some extent from clothing, props or background.

USING BACKGROUND COLOR

The area of dominant colour in your painting does not have to be in the subject itself – it can be the background. Often this part of the image is deliberately underplayed – sometimes a neutral background has been chosen to begin with, and sometimes the

Colour studies
Bold colour turns an everyday subject into a more impactful, personalized image. These two self-portrait studies are painted in gouache on coloured paper, which keyed the effect of the dominant colour from the start. A figure naturally forms the focal point of any painting, so the background can be made stronger without distracting attention from the subject. The blue makes a quieter image, with red, burnt sienna and white counterpointing the main colour. In the red painting, the highlighting is added in related colours. Red is the most active, dynamic colour, and has the effect of pulling the background closer to the viewer.

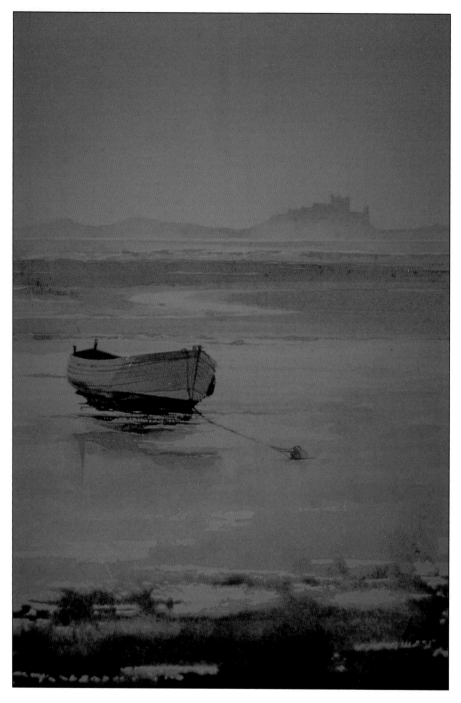

◄ NORTHUMBERLAND BEACH
David Norris • Watercolour
The depth and subtlety that can be achieved with watercolour washes work particularly well in relation to a dominant colour theme. Hues and tones can be enriched or intensified by economical means, and contrasting elements can be played in gently, using soft colours and shapes.

► POPPY FIELDS
Suzie Balazs • Pastel
The shapes in this pastel painting are relatively simple; there are other important factors that make the composition work so well. One is the different characteristics of the dominant greens – from the intense blue-green to sharp yellow-green, darkening to black in the background. The other is the variety of marks on the surface, the network of dashes and scribbles forming the foliage textures, accented by the tiny, vivid red dots of the poppies.

background's own local colours are ignored. But a strong background colour to a still life or portrait – say, a vivid red or strong bright yellow – can have an interesting effect, sometimes greatly enhancing the picture's visual impact.

This has to be judged very carefully so that it does not destroy the spatial arrangement of the composition. An intense hue will seem to draw the background closer, but if its tone is correctly judged against the colours and tones of the central subject and positive forms are clearly defined, it should stay in the background, yet give strong character to "negative" shapes.

SURFACE INTEREST

If the colour range of your painting is creating a sense of uniformity, the surface needs to have some physical activity and variation, otherwise the image could appear flat and uninviting. You can try different technical approaches that will give the painting greater depth and layering. These can be applied either purely for the visual interest they contribute to the painting, or in order to render something of the texture, mood or atmosphere of the subject.

For example, a flat wall in an interior scene could

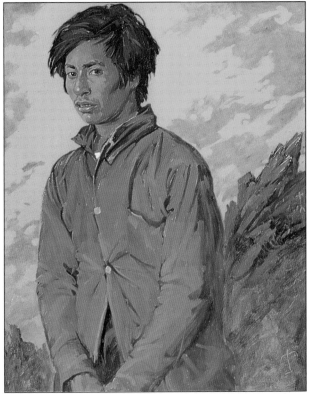

◀ **MOUNT MANUEL MORNING**
John Houser • Oil
This portrait conveys a disturbing impression which stems from the combination of the subject's pose and expression and the abstract, formal qualities of the picture. Fierce brushstrokes and a clash of strong colours exaggerate the mood.

be rendered with broken colour, using closely related hues and tones to maintain a unified surface. Alternatively, it could be built up with layers of washes or glazes and scumbling to provide underlying activity, and then overlaid by a more uniform final layer to bring it all together. Broken colour is also an effective way of dealing with the variety of textures in a landscape view; or you can use carefully modulated, layered "veils" of colour both to create solid masses in the foreground and to suggest the hazy quality of the more distant view. These techniques also work well on a smaller scale, for still lifes and portraits, for example, provided the variety of marks you make still add up to a convincing sense of form.

You can also make use of any organized pattern areas in the subject to introduce surface interest and colour counterpoints while keying the image overall to a distinctive colour theme. This might come from manufactured patterns, such as those of furnishing fabrics, clothing and domestic china, or from natural organic patterns, such as decorative flower petals and complex leaf-vein networks.

EXPRESSIVE COLOR

As can be seen from the paintings shown throughout this book, even the most naturalistic rendering can include bold or unexpected touches of colour, and artists often enhance the colour values of relatively subtle variations in their subject to give a picture a more dynamic visual expression. Colour is one of the most expressive and personal elements in painting, and a strong scheme of colour can give even a mundane subject a distinctive character or mood.

One approach is simply to exaggerate existing colours. Subtle touches of reflected colour, for example, could be given a more dominant presence, or a strong hue used to represent a basically neutral colour with a slight bias towards one of its components. The idea of using colour as tone (see page 93) also provides a way of dramatizing a subject, by enhancing the colour qualities of mid-tones and darks.

Where you depart from the colour balance provided by your subject, you have to be even more conscious of the way the colour relationships work in the painting itself. There is perhaps more subjective judgement involved in organizing these kinds of colour interactions, as the question of whether certain colour combinations appear attractive or disturbing is influenced by personal preference and intention.

▶ **STILL LIFE**

Paul Powis ● Acrylic
With clearly stated colour contrasts and very free brushstrokes working in and around the shapes, the artist produces an unconventional still life that has great vitality. There is an exciting tension between the surface activity and the sense of form and space.

▲ **INTERIOR WITH BLUE LAMP**
Sara Hayward •Acrylic
The potentially harsh effect of a
colour scheme composed only
of primary and secondary
colours is softened by the fluid
qualities of the paint texture.
Although the colour contrasts
are extreme and dynamic, the
glazed and layered patches of
paint create variable edge
qualities that in places allow one
colour to drift into another.
Whereas bright colours tend to
flatten spatial description, the
lines of the composition help to
direct the viewer inward.

ANALYSIS
CREATING ATMOSPHERE

Colour is in itself a powerful tool for conveying mood and atmosphere, but a strong colour bias in a painting needs to be broadly interpreted through the range of the palette and the activity on the painted surface, so the picture has plenty of visual interest. In the paintings shown here, each artist has selected a distinctive colour key, both employing the yellow/purple complementary colour pair in different proportions.

The contrast between the two paintings illustrates how a basic

Loose strokes directed towards the centre of the image create a dynamic force, drawing the viewer into the picture.

The balance of warm and cool colours is variable where different shades in a selected colour range interact continuously.

THE ROAD HOME
Simie Maryles • Acrylic and pastel
The darkening landscape throws emphasis on the drama of the sky, which gains a vivid sense of space and movement from the turbulent, fragmented colours. All the hues seem hurled together at full intensity, but

despite the vigorous, gestural marks, the artist has controlled the colours carefully so that each one is enriched by its neighbours.

Darkness on the road is colourfully conveyed with naturally dark purples and blues shot through with touches of intense red.

Tiny accents of cool colour among the darkest foreground tones complement the pinpoints of yellow light in the distant background.

principle such as using complementaries can also be a highly versatile one. In one painting the yellow dominates; in the other, the purple. In each case the dominant colour is counterpointed by its complementary, and the palette incorporates a range of related colours and descriptive tonal changes. The variation of marks on the surface creates broken-colour effects that integrate the individual hues and tones without lessening their impact.

The compositions are similar, with an even, low horizon line placing the landscape under a large sky. But the colour moods are very different: the yellow painting has a serene, langorous mood, the purple painting a much more dramatic atmosphere.

Vertical stresses in the sky create a veiled impression of heat hanging over the land.

Hazy, atmospheric colour has been achieved due to rubbing and blending the pastels on heavily toothed pumice paper, which grips the colour particles.

Strong tonal contrast on the horizon emphasizes the brilliance of the reflected light.

Bright yellows are intensified by contrast with gentle, cool mauves.

FEN LIGHT
Geoff Marsters • Pastel
The artist combines technical skill in applying the pastels with expert judgement of colours and tones to re-create the shimmering, dense atmosphere of a hot summer day. The way the composition is organized enables us to appreciate the division of land and sky, but they are at the same time united by the dominant colour theme. The colours are not realistic, but give a real impression of place and time.

REFLECTION AND TRANSLUCENCE

Reflection is an important element of almost any subject you might paint. Reflected colours and tones, as well as strong highlighting, are most apparent on materials and objects with a very smooth, shiny surface, but everything you look at is described by light, and the appearance of many things is subtly modulated by colours reflected from their surroundings.

I f you are painting objects, figures or scenes, you naturally attend to the basic pattern of light and shadow, otherwise your paintings would seem very flat and simplistic. Often you can produce a perfectly adequate picture by shading tonally, especially if you can introduce some colour into highlights and deep shadows. Reflected colours are in some ways the "icing on the cake", but they can lift a painting immensely, adding an extra touch of realism that the viewer perceives semi-consciously. In a portrait, for example, the colour of the sitter's clothing may cast a bloom of colour onto the skin tones around the jaw and neck; in a still life, reflected colours between adjacent objects may introduce small flashes of colour that cross the boundaries of separately defined shapes.

The reflected colour may sometimes appear as though imposed on the local colour, or it can suffuse it more gently, producing the effect of an intermediate colour or tone. With extremely shiny materials the visual impression is complex because so much of the surface is composed of reflected colours and tones, and the patterns these make can appear very intricate and random. Metals are the most obvious example, but similar effects can occur with, say, highly polished wood, glossy plastic or glazed pottery. Often it is very difficult to see where to start, or which elements are most important.

Translucent and semi-transparent materials create similar problems for different reasons. Here you are

WASHINGTON D.C. REFLECTION
Sandra Walker • Watercolour
Modern glass-walled buildings camouflage themselves with reflection of their surroundings. The artist has recreated the intricate detail meticulously, at the same time achieving a complex, painterly style of pattern-making. The strong tonal structure of the painting is assisted by the orderly grid of glass panes.

seeing background colours and tones coming through the material, but the object may also have local colour of its own, and tonal modelling or reflected colours overlaid on that. Again, what you see is a complex pattern of shapes in varying colours and tones, so how do you deal with all those layers of information?

HIGHLY REFLECTIVE MATERIALS

A significant characteristic of materials with a very high shine is that the transitions between colours and tones on the surface, whether local colours or reflected ones, are frequently hard-edged and abrupt. The darkest tone can be immediately adjacent to the strongest highlight. Reflected colour can appear very pure, positive, and quite unlike the natural colour of the object or surface on which it appears. Even among the mid-tones and more muted colours, the changes often appear quite well defined, although there may also be much subtler gradations.

To capture the effect of extreme shininess, it is necessary to make a bold play of these contrasts. This may present two practical problems. Firstly, the pattern of shapes you put down can look very strange and disjointed until you have added enough information to make it cohere as a uniform surface effect. Secondly, it can encourage you to adopt a hard, graphic style that makes it difficult to integrate different materials and objects within one painting.

The first problem is overcome mainly by perseverance. It is very satisfying when, having identified a series of individual shapes and colours, you reach a magical halfway stage where they begin to come together. There is, of course, a risk that the magic will not happen, in which case there are some technical solutions you can apply, such as an all-over glaze or wash of a well-chosen colour that helps to unify the pattern, or a reworking of middle tones. Occasionally you may lose the picture altogether, but with more experience, as you develop both your skills of observing and of rendering, that disappointing prospect will become less and less likely.

The graphic nature of such subjects does not inevitably mean that you have to convey them graphically. Your medium will to some extent help you to make decisions about how to work. For example, with watercolour you would not obtain the right effects by working wet-into-wet because this produces soft fusions of colour and undefined edges, but you can build up washes in layers and let colours and tones overlap slightly, so they are drawn together. You can do the same with

SUGAR CASTER AND GRAPEFRUIT
Ronald Jesty • Watercolour
Sharp black and white contrast brings up the high shine of the sugar caster, but the artist has also found a subtle range of metallic neutrals that model the whole form and suggest both local and reflected colour. The relatively hard-edged treatment of the metal is nicely contrasted with the pitted, irregular textures of the toast and fruit.

thinned acrylic glazes. Conversely, with oils, which have such a substantial texture of their own, you can put down rich, painterly brushstrokes which may not be hard-edged but will keep their shape and direction individually so that a detailed pattern begins to emerge. The same applies to acrylics used thickly.

In any of the opaque media – oil, acrylic, gouache or pastel – you may find that a loose approach needs some sharpening in the final stages – a clear, bright highlight or hard, dark edge – and even quite small touches can make the subject come alive. If you have lost the light tones in a watercolour, you can add a little opaque body colour towards the end – but do not overlay that with washes, or the chalky effect of the white will spread and mingle with the new colour.

COLOR AND LIGHT

One of the problems with highly reflective materials is that their surface patterns are changing all the time. If you are working in daylight, even on an overcast day, you will find that the position and extent of highlights

and shadows change subtly as the light from outside gradually changes direction. In natural or artificial light, simply moving your head fractionally as you observe your subject can alter the surface effects that you see.

This can be inhibiting, but you have to start somewhere, and once you have started you cannot keep changing every element of the picture all the time. In most cases, it is easiest to start with relatively large shapes, then break them down and work into the detail bit by bit. Look for the connections – the same colour appearing on different parts of the object – and the clear contrasts – the brightest highlights and darkest shadows. Almost certainly, your rendering will simplify the range of visual qualities somewhat, but this does not mean that you are ducking the problem; some simplification is nearly always necessary. Try to keep your eye on essentials, and if you become aware of a major change, decide whether it will help or hinder the interpretation as far as you have got. If adding a new or transient element means that you will have to rework everything else, feel free to ignore it if the picture is already working well.

COLOR COMPONENTS

Defining colours exactly is often difficult, particularly with metals, which seem to have a distinct colour of their own but also change so much under the light. It is much easier to define the relationships of tones. You may find that you are approximating colours, but this will work if you eventually get all the relationships of tone and colour right. For instance, the highlights on gold, copper or brass may seem very high-toned but also quite colourful, so pure white will not do, while a pale yellow or orange-pink can look too rich. Once you have added the darkest tone, however, and made the links through the mid-tones, the highlight will appear much brighter. It may be necessary to exaggerate the contrast between light and dark slightly, to make the highlights sing.

If a metal object is the lynchpin of your composition, it is worth doing some quick colour swatches to find suitable mixes for the main colours and tones. Silver, for example, tends to have a yellow-grey cast, while the silvery alloy used for food cans is often blued. Copper is distinctly red, and brass a smoky yellow, deeper in tone than the bright tint of gold.

TRANSPARENCY

Plain glass and clear plastic have no colour of their own – all the tones and colours that you see are transmitted or reflected. These form a basic pattern, but this is also shaped and ordered by the thickness of the material and the shape of the object. You often see strong darks in the base of a glass tumbler or vase, for instance, where the material is thickest, and brilliant, pure white highlights on a curved rim or faceted edge, while curves and edges also provide linear emphasis. Because the surface is shiny, and you can be looking through several "layered" surfaces in a hollow glass object, you also see strange effects of reflected colour, sometimes very strong and clean, sometimes vague and atmospheric.

The shapes you see within a glass or plastic object are typically complex because the material refracts the light and "bends" transmitted shapes. Objects standing behind the glass are often heavily distorted. Any pattern on or within the object – as in a cut-glass vase – makes a number of additional edges and facets that further break down the pattern of tones and colours seen through it.

If the background is busy, or if the glass itself acts as a container for complex forms such as flower stems, you will have a wonderfully intricate, kaleidoscopic pattern. How much of that you want to deal with, and in how much detail, depends on the balance of the composition as a whole. If the glass is a relatively small element in the group you may wish to simplify so that it does not jump out from among other simpler objects. On the other hand, you might want to go into close-up so the patterns within the glass form the focus of the composition.

AUBERGINES AND RADISHES
Suzie Balazs • Pastel
It can be difficult to obtain the brilliant sheen of a highly polished surface with the naturally grainy textures of pastel strokes. Although using quite a loose technique, the artist has separated the planes of colour and employed warm/cool and dramatic tonal contrasts to describe the shiny aubergine skins.

TRANSLUCENCY

A material that is translucent but not fully transparent, such as smoked glass or thin fabric, combines some of the visual effects of glass or metal – it has a colour of its own, it reflects from its surface and also transmits colours and tones. But translucency commonly has a slightly hazy effect, without the powerful contrasts seen in reflective and transparent materials, and the gradations of colour and tone are less abrupt.

The key to all of these subjects is to bring everything to the surface – interpret the shapes and colours as a kind of jigsaw of interlocking elements rather than receding layers. You need to identify very subtle colour relationships where background colours are merged with the colours and tones of the intervening material and the play of light acting upon it. However, you may be able to employ techniques of layering your paint surface to handle some visual effects. Scumbling, a thin veil of semi-opaque colour brushed lightly over underlying layers, has exactly the subtle, gauzy effect of see-through fabric. Drybrushing, a more emphatic, broken-colour effect, can also work well.

But remember that the form of the object or piece of fabric affects the character of underlying shapes – think how the folds in a fine muslin curtain, for example, can distort the lines of a window frame behind. You cannot make a formalized picture of what lies behind and then scumble the "veiling" over the top, however tempting such a straightforward solution may seem.

WATER

This is a subject that combines all the characteristics of reflectiveness, translucency and transparency, often with the added complication of movement. A glass of

EASTERN VIEW
Timothy Easton • Oil
The exact quality of the translucent drapes is conveyed through subtle colour variations within a narrow tonal range and drybrushed textures that create a veiled effect. These elements are beautifully integrated with the distorted patterning of direct and reflected light through the window.

HENLEY BACKWATER
Hazel Soan • Watercolour
The still water has no colour of its own; its surface plane is entirely described by the upside-down mirrored reflection of surrounding trees. The artist has made a bold and successful decision to let the dark leaf patterns on the water stand against a background of pure white.

still water can be treated in much the same way as solid glass, by looking for a pattern of shapes, as can a flat pond or lake that reflects like a mirror, but a trickling stream or rolling sea forms a moving pattern, and the colours are not easy to define. Not only do they come from both reflected and transmitted colour; they are also changing all the time.

Such problems are only solved by careful observation and a decisive approach to selecting from the visual information in front of you. There are various pictorial solutions and some technical effects that can help you to achieve a sympathetic rendering. One of the typical errors in painting the sea, for example, is that the shapes of the waves can look too solid and fixed. You need to find ways of loosening up the shapes and giving them depth: layering techniques are one solution, making use of the translucency of diluted paint. With opaque colour, you need to keep the brushwork active and make use of broken colour effects. Tonal balance is an important element, perhaps more so than precise nuances of colour, because the depth, movement and surface effects of water are all dependent on the play of light.

ANALYSIS

PATTERNS

OF

LIGHT

In both of these paintings an everyday subject is frozen into a unique, striking image which owes its intensity to the qualities of light. Light reflecting from and transmitting through different kinds of surfaces and materials creates a dynamic pattern of colours and shapes. The presence of water acting both as a mirror and transmitter breaks up colours and tones in a variety of ways. The artists have succeeded in finding the specific colour values through which an opaque medium

Brilliant flashes of local colour emphasize the strong lighting.

The glinting surface is conveyed with bold colour and rapid, individual brushstrokes.

Hard-edged shapes establish powerful contrast of light and shadow, although the tones are not high-contrast.

Dark tones break up the pattern of light on the water vertically and horizontally, suggesting both cast shadows and ripples on the water surface.

SWIMMING LESSON
Andrew Macara • Oil
The intensity of the light is contained by the shadows of the window frame, painted in a low-key, mid-toned greyish purple. This enhances the warmth and brilliance of the yellow and pink blocks on the swimming pool surround. The contrast extends across the water with cold, deep blues

shadowing the high-key greens and blue-greens. In this case the apparent colour of the water — the clear, bright blue — sets the bias of the reflected colours and lights, but touches of pure yellow help to create the surface sparkle.

Loose dashes and dabs of mid-toned flesh tints show the water to be translucent as well as reflective.

can represent pure luminosity.

An essential element is the balance of values that pushes the lights to the highest key. Yet in neither case does this depend on a stark or extreme tonal contrast — both paintings contain a wide range of mid-tones and the most brilliant lights are not pure white. The artists have made use of distinctive complementary and warm/cool contrasts, creating space, depth and modelling by colourful means. Brushwork and the surface textures of the painting also play an important role in constructing a fully descriptive picture.

Brilliant, warm pink is subtly graded to give the effect of light transmitted through the white stripes of the deckchair canvas.

To obtain this degree of detail, the pier was painted with relatively high contrast, then softened by spraying white (through a spray diffuser) over the colours.

Flatly finished areas of high-key pale pink, appearing to reflect the full intensity of light, contrast strongly with the darker tones of the deckchair and the cold blues of the ironwork.

In the reflection on the wet ground, the deckchair stripes are broken in shape and also downgraded in colour value.

Lightly "pebbled" textures on the stone flags under a thin sheen of water were created by sponging colours into a damp wash of paint.

Cool and neutralized colours in the foreground enhance the luminosity of the warm tints above.

BANK HOLIDAY MONDAY
Philip Dunn • Gouache
Although there are unifying links throughout the painting, the colour ranges clearly divide foreground from background. This focuses attention on the vibrant, warmly lit subject against the greying, distant view. The colours are cleverly integrated with the different structures of the shapes, so that firm lines and strong contrasts at the centre of the picture stand out from the more complex shapes and textures of the sea behind and the glistening reflections below.

Reflections on metal

Each of the metals in this still life has a characteristic colour and degree of shininess. To complement the group, the background fabric, though plain-coloured, has a light sheen. Karen Raney uses a very direct oil painting technique to build up the colours, working wet into wet.

She has a challenging task, as the very shiny surfaces reflect all kinds of colour influences within the room, and even change with the pattern of light in the studio as the day progresses.

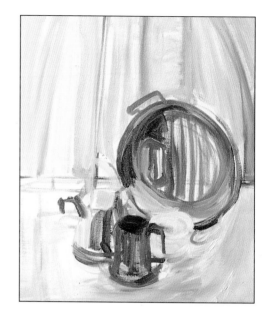

1 Although the subject contains some precise, hard-edged shapes the artist prefers to block in the overall impression very loosely to begin with, looking at basic variations of colour and tone.

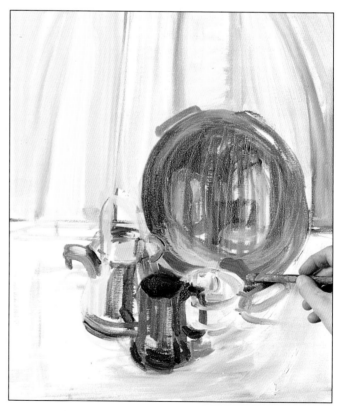

2 She deals immediately with the interaction between local colour and reflected colour. The warm copper colours and cooler yellows of the brass are modified with reflected greens, and the silver and pewter with touches of blue. Tones are gradually strengthened to develop contrasts.

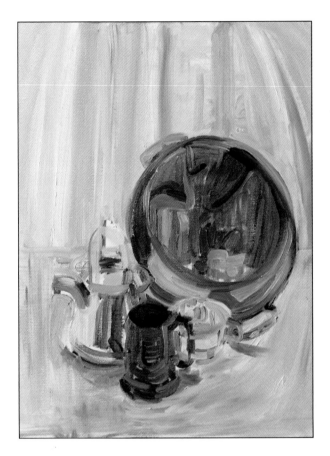

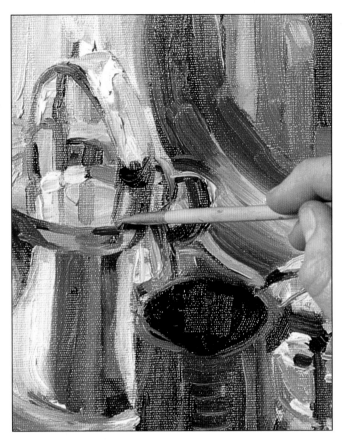

3 The larger shapes remain loosely defined but the reflected patterns are already intricate and colourful. The warm/cool balance of the picture is made more complex by the addition of crimson in the coppery reds and violet in shadows around the silver pot. These also intensify complementary contrast, against the greens and yellows.

4 The shapes begin to firm up as the smaller details of the reflections add to the definition of form. Touches of heavy dark tone and brilliant highlights help to shape the rim and handle of the brass jug. The yellows contain many subtle variations of tone and hue, from warm orange-pinks to cold, pale greens, which model the curved surfaces.

The palette The artist chooses a relatively broad palette of seventeen colours and lays them out in a logical sequence from red through yellow to green, then blues, violet and browns. She has selected three true reds, yellows and blues, incorporating varied tones and biases, and two tube greens – the blue-green viridian and deep, yellowish sap green. Light and dark ochres and siennas are used both for mixing local colours and modifying the brighter hues.

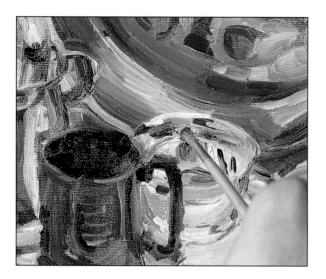

5 The same treatment is applied to the copper pan and silver dish, breaking down the reflections into smaller shapes and more detailed patterns. The colours are brushed on more thickly at this stage, with the brushstrokes following the directions of curves and edges. This helps to keep the forms unified despite the colour variations.

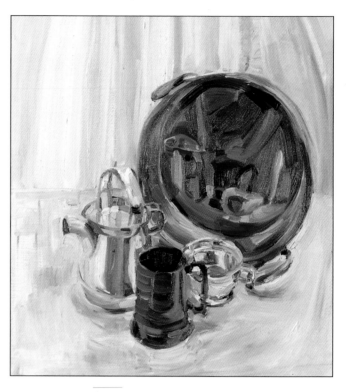

6 When you focus on a still life like this you do not see the sources of the reflected colours, so there may be striking, unexpected touches, like the patches of bright green and red. But these have to be integrated in a way that does not disrupt continuous surface planes.

7 The shinier the metal the more contrast between the tones and colours. The inner and outer surfaces of the silver dish sparkle with bright colours and strong tonal contrasts. On the duller surface of the pewter mug, the transitions are low-key and muted, although the dark tones contain subtle contrasts of red and blue linked with intermediary shades of neutralized purples. The pewter highlights are pale, but not pure white.

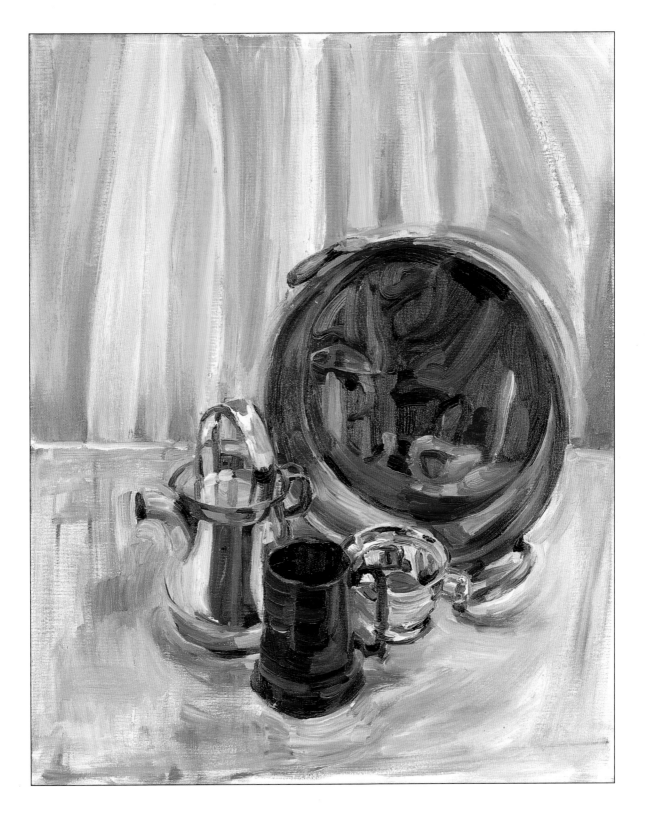

8 The finished rendering is very vibrant. The artist has clearly enjoyed the complexity of the colourful reflections, and has made the most of the contrasts while also picking up the subtler shadings. Notice how the other objects are themselves reflected in the base of the copper pan, their colours modified by the warm copper tints.

Painting colored glass

The arrangement of this still life is kept simple because the main colour interest lies in the actual shapes and materials of the glass objects. Even so, the artists see a complex layering of translucent colours and reflective surfaces. Working in

pastel, Hazel Harrison has to use the opaque medium delicately to convey the fragile layers, and she employs lightly stroked "glazes" and hatching to overlay the colours. Hazel Soan works in watercolour, possibly the ideal medium for this kind of subject, because the transparency of the paint naturally corresponds to qualities in the subject.

1 The artist chooses a neutral mid-toned grey paper to work on. She sketches out the still life with loose, broad strokes, immediately starting to indicate the tonal pattern and elements of local colour by selecting different types of blue to key in the main shapes.

1 Patches of masking fluid are laid down to reserve white highlights, and whole shapes are then blocked in using well-diluted light washes of colour. The colours are ultramarine, cerulean blue and Hooker's green dark for the objects, alizarin crimson and yellow ochre for the warm background tones.

2 The artist chooses to continue working with a restricted palette. She starts to model the internal shapes of the jar with deeper ultramarine washes and keys the same tone for the shadowing on the rim and neck of the left-hand vase. Mid-toned washes are modified with a touch of cerulean blue.

2 The surfaces of the fabric and jar are built up with glazed side strokes, introducing light and dark tones and reflected colours. To maintain the translucency of the vases, the curves and edges are described with linear marks and soft hatching.

3 The artist has themed and linked the colours to show local variations and reflected colours – the true blues of the jar, soft purplish-blues of the left-hand vase and pale turquoise in front. Because the glass objects overlap in transparent layers the edge qualities remain as important as the internal shapes and colours. The colours are softly veiled where they overlap, but final strengthening of bright highlights and dark shadows re-establishes the outlines of the objects firmly.

3 The same careful technique is applied to the foreground shapes, keeping control of the damp colour areas to vary between hard and soft edges. Pale touches of yellow ochre and alizarin crimson show where the warm background colours are transmitted through the glass.

4 With the masking fluid rubbed away to reveal the pure whites, the balance of tones is subtly adjusted to intensify the modelling of shapes and the tonal pattern of the shiny glass surfaces. The artist adds some delicate modifications to the local colours of the vases, enhancing the mauve and greenish hues before strengthening the background colours slightly to heighten the contrasts and show the cast shadows and reflected colours on the fabric.

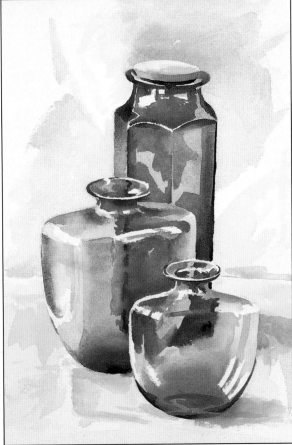

PATTERN AND TEXTURE

Colour variation in a painting frequently relates to surface detail, but surfaces are also components of form and space. Using the complex effects of patterns and textures in your subject can help you to give a composition more decorative impact, and if they are carefully analysed and represented, they have an equally important descriptive role. Both elements enrich the basic structure of a composition.

T he colour components of a manufactured pattern are usually obvious – the patterned material or object is designed that way and part of its function is to be decorative. With textures, it may be initially less obvious that colour is the key to your rendering; but even where the local colour is consistent throughout, the texture is typically formed from a pattern of light and shade striking different surface levels, which you must interpret as variations of colour and tone.

To some extent, you can use the texture of the paint and your brush marks to assist the illusion, but you need to be aware of the limitations of this procedure. It would not necessarily work to describe a rough-plastered white wall by applying impasto white paint to your canvas in physical imitation, because the lighting on your painting would always be different from that falling on the original surface as you saw it. You would need to use colours to "fix" your description of the ridges, swirls and cracks in the plaster creating highlights, shadows and mid-tones.

You will find different kinds of pattern and texture in many subjects, but you do not have to make a major feature of them just because they are there. In a landscape, for example, you might often ignore the physical texture of grass or foliage and regard them more simply as patches of colour. The same is true of brickwork or roof tiles in a townscape – you can focus simply on the broad impression of their overall colour; but their pattern

qualities can also help to vary the surface qualities in the painting, especially if the picture already contains a lot of flatly coloured planes.

You could choose to work on a still life or interior view in terms of basic shapes and forms rather than distinctive textures and patterns, but in general, the more intimate the scale of your picture, the more surface detail plays an important part in both increasing its realism and providing decorative interest. In setting up a still life or posing a figure, artists often choose patterned or textured objects, clothing or accessories to offset smoothly modelled forms. These naturally contribute variations of local colour and tonal range, and may supply incidental colour accents that can enliven the image.

SUPERIMPOSED PATTERNS

Patterns that are printed on or woven into fabrics, wallpaper, floor coverings and so on have a purely decorative purpose. They have been designed, and have some deliberate logic or scheme. But the artist using pattern elements in a painting constructs another scheme – the organization of the composition – in which the detail of the existing pattern has to be integrated with other visual elements as well as being related to form, light and shadow.

When you are working with surface patterns there are two distinct levels of information that you need to identify. One consists of the actual colours and shapes in the pattern, and how much of them you intend to reproduce in your picture. The second is the way form and structure modify the shapes and colours in the pattern. On a decorated vase, for example, the pattern will be distorted as it wraps around the main form, and in clothing the underlying form of the figure will shape the fabric, making folds and tucks that disrupt the uniformity and sequence of the pattern.

MOROCCAN STILL LIFE
David Napp • Pastel
Allowing the strong, all-over pattern to fill the image area completely produces a striking abstract effect from which the solid forms gradually emerge. The local and reflected colours of the fruits are also treated as pattern elements with heavy, broken pastel strokes, but they are strongly shaped against the active background. Pastel is the ideal medium for such a bold colour interpretation, because of its immediacy and expressive qualities.

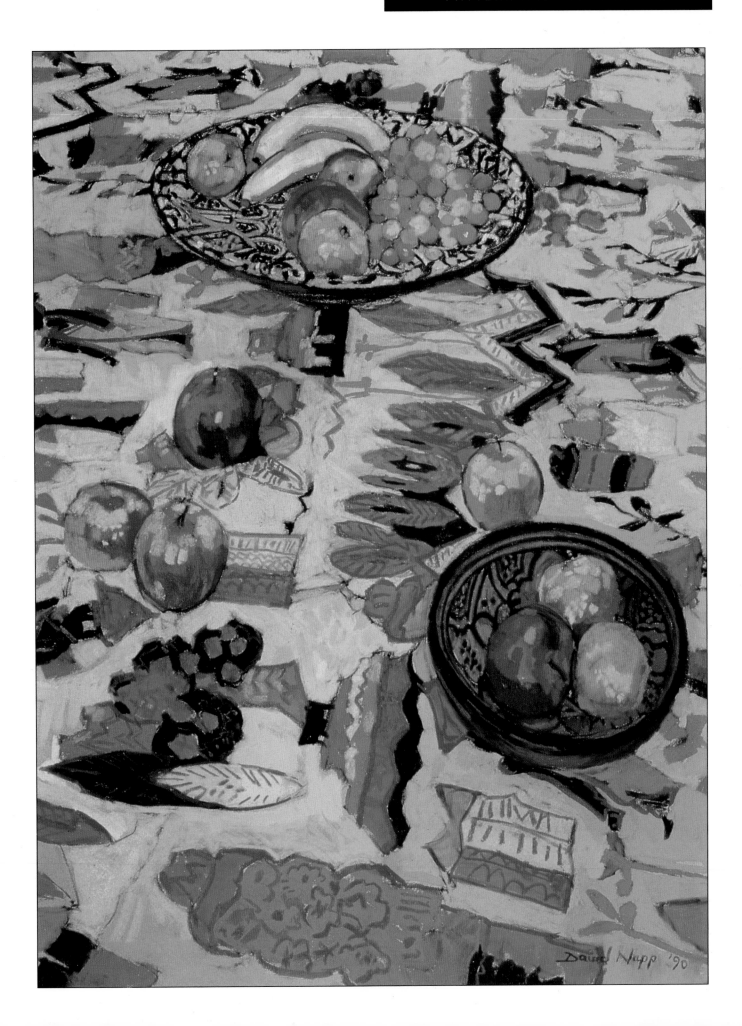

Even with a flat patterned surface, such as a papered wall or carpeted floor, the shapes in the pattern are modified by the angle of the surface in relation to your viewpoint and the increasing distance as it stretches away from you on a vertical or horizontal plane, and the colours may be affected by both variations in the light levels and cast shadows cutting across the surface.

Thus a pattern that you introduce or select simply to enliven a composition can create a complex visual problem that might become a subject in itself. But normally, you will be looking for ways to maintain the decorative impression of the pattern at the same time as integrating it with other features of your composition. You may need to subdue the colours of a patterned object or area that is relatively distant so it does not jump out of the picture ahead of nearer objects. With a pattern that is quite complex and detailed, you can simplify and select, using it to vary surface interest and provide colour accents. In both cases the relative scale and values of the shapes and colours are the key factors.

BERLIN KIMONO
David Remfry • Watercolour
Patterns create focus and complexity even when the colours are relatively subdued. In this painting the model's pose effectively cuts the picture in half diagonally, so the detail is concentrated in the lower part and is nicely offset by the quiet background. Although the patterns of the hat and robe are delicate, the way they are contrasted with heavy, dark colours is surprisingly appropriate. The stronger but still muted colours of the rug help to frame the contrast, but also link the tones.

NOSTALGIC EVENING
John Sprakes • Acrylic
In this clever, slightly surreal painting, the repetitive shapes of the wicker chair back and the butterflies contain both texture and pattern elements. Heavy tonal painting contrasts with finer surface detail.

STRUCTURAL PATTERNS

One major feature of patterns is the repetition of identical or similar shapes. Many man-made and natural objects form a kind of pattern element because they are constructed of multiple similar units. Architectural detail is full of patterning – brickwork, tiling, steps, railings, trellises, fences. Individual buildings and whole streets form an overall pattern of shapes because they are orderly and consist of repetitive geometric planes that are clearly defined. Natural patterns are often clearest on a small scale – radiating flower petals or leaf veins, or the highly structured forms of a honeycomb or pine cone, for example. There are also patterns that derive from human intervention in the natural order, such as the "patchwork" effects of farmed fields or formal gardens.

All of these items combine elements of pattern and texture, especially when you consider the colour values.

Brickwork has a relatively uniform local colour, especially from a distance; but you can see within this both the pattern made by the mortar lines running between the bricks and individual variations of surface texture, showing as changes of colour and tone. A pine cone has a faceted surface of interlocking scales, which also have a particular texture. A formal garden has an overall pattern broken into smaller areas of varied pattern and texture.

These things make attractive subjects because of the combination of colour variations and different surface features that you need to find pictorial equivalents for, either in the way you structure the combination of hues and tones in your image, or by matching suitable techniques to the specific characteristics of your subject.

► **CHINESE TEAPOT**
John Martin • Oil
The perfect integration of colour
and pattern gives this simple
composition an unusual charm.
The softened edges of the
shapes and superimposed
patterns gently define planes
and curves.

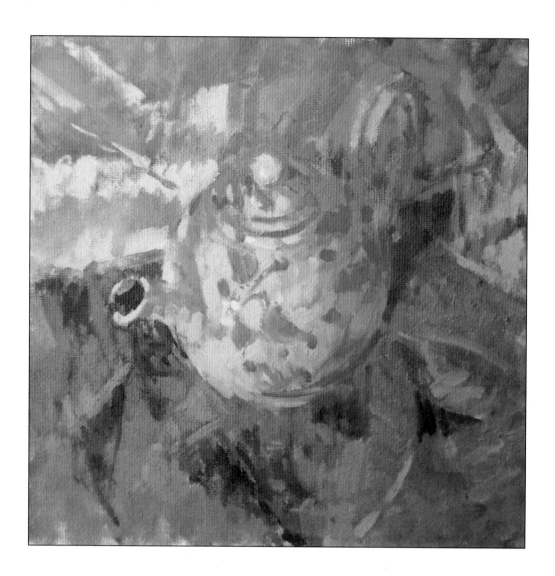

▼ **OLD TOWN, HASTINGS, FROM
WOODS PASSAGE**
Pip Carpenter • Pastel
The regimented shapes in this
townscape create patterning
that also describes structure
and depth. The colour detail and
surface activity of the pastel
marks break up the
architectural regularity.

IRREGULAR TEXTURES

Textured surfaces that have a seemingly random composition can be more difficult to interpret than those that have a definable pattern element – there is no obvious place to start, or framework on which to hang your drawing and painting techniques. Basically, there are two ways of handling it. The first, which has parallels with a highly reflective surface, is to regard the textured surface as composed of differently coloured, individual small shapes and marks which you treat quite delicately and separately until they add up to an overall impression. The other approach is to treat the surface as a kind of massed texture that can be simulated with paints. Fine effects might be represented by drybrushing, spattering or stippling, for example; and rougher, bolder textures broadly splashed and sketched with loose brushwork, impasto applied with a brush or knife, or heavy colour blotted with paper or rags.

As with pattern, you need to keep a sense of underlying form – the shape of the object that the textured surface represents – and location within the picture, meaning that the texture can appear as a subtle contrast to other visual elements or as a primary, dominant feature. Tonal variation is often the most important factor in the colour rendering of irregular textures, but many natural materials – seaside rocks, tree bark, massed foliage – also incorporate distinct variations in hue, or variable colour biases.

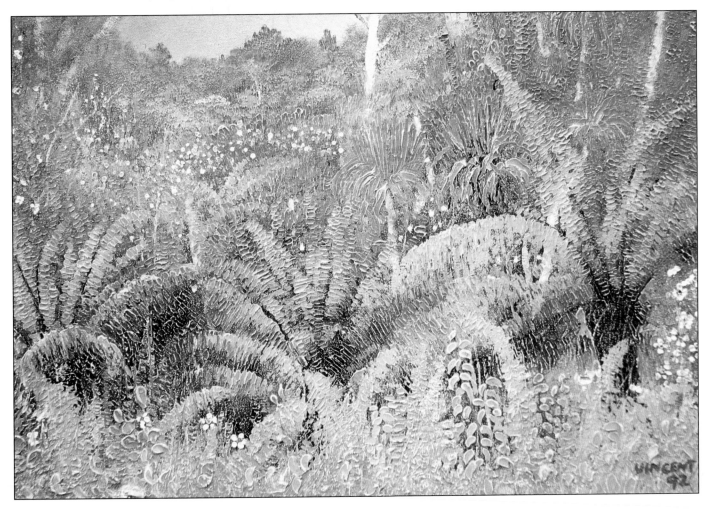

NATIVE BUSH IN CENTENNIAL PARK, MILFORD
M. Vincent ● Oil
In this interesting landscape interpretation, the modelling of paint layers represents the natural foliage textures. A relatively restricted palette of colours makes the marks clearly visible and active.

ANALYSIS

TEXTURAL STUDIES

Both of these paintings, though completely different in style and execution, demonstrate a detailed focus on natural textures that creates an exciting image from a **relatively simple subject. In each case the artist has cropped in close to the subject so that it is centred within the picture frame, thus eliminating the distraction of**

Areas of light and shade are separated with emphatic edge qualities to the strokes.

Shadows incorporate warm and cool colour influences among the darker tones, giving complexity and depth to the negative shapes.

Background colours and tones are subdued to convey distance and throw the foreground into high relief.

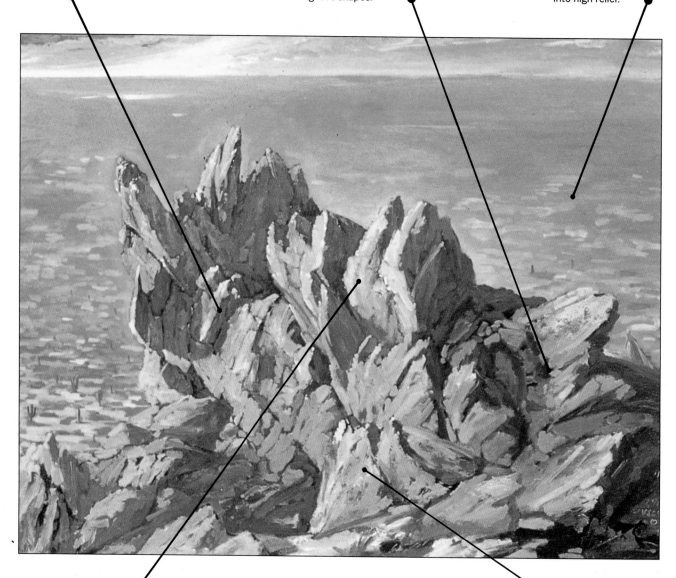

Warm, yellow-tinged neutrals are contrasted with high-toned, cool grey-greens for surface modelling.

GATHERING PLACE OF EVENING LIGHT
John Houser • Oil
This painting is an excellent example of how the impression of texture is evoked through careful study of a pattern of light and shadow. The artist has

enjoyed using the bold tonal contrasts and gentle colour nuances of the evening light to describe the monumental rocky structure. He has created a surprisingly broad palette of neutrals, ranging from pure greys to subtly devalued hues.

Heavy, dragged brushstrokes enhance the variety of surface texture.

broader surroundings and focusing the attention on particular qualities.

In both cases, too, the medium is perfectly adapted to the image. The viscosity and opacity of oil paint gives weight and substance to the rocky outcrop; the delicacy of transparent watercolour reproduces the fine tissues of the flower petals and the glossy sheen of its stem.

Controlled tonal modelling brings forward the smooth texture of the flower stem against the flatter greens of the wood panel.

The pattern of the wood-grain is distinct but unobtrusive, detailed with a fine brush and a colour just slightly darker than the wash beneath.

Subtle variations between warm orange-red and cool blue-red suggest the folds and curves of the flower petals.

Linear brushstrokes help to describe both the patterning of local colours in the flower and the surface texture of the petals.

AMARYLLIS
Richard French ●
Watercolour
Qualities of pattern and texture are frequently combined in natural subjects, as in the streaks of colour following the striated texture of the amaryllis petals. This detailed study interprets the striking red/green complementary contrast with delicacy and restraint.

DEMONSTRATION

Form and pattern

This particular combination of patterned objects and materials has an attractive scheme of complementary colours, from the bright oranges against the strong blue of the background fabric to the subtler deep blues and warm browns. This underlying theme helps to link the different types of pattern and texture in the arrangement. Initially, the subject looks complex, but the interaction of shapes and patterns provides a number of reference points from which

the accuracy of the painting can be checked at various stages. Colour contrast has to be built up gradually and the effects checked by eye. Judy Martin uses acrylic paints which, since they are quick-drying, enable her to overpaint and rework details continually.

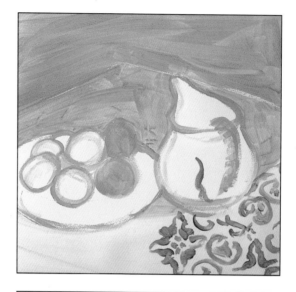

1 The main shapes in the composition are loosely drawn with a bristle brush in cadmium orange and yellow ochre. To define the basic planes of the composition, the background is lightly glazed with a mixture of burnt sienna and yellow ochre, and the blue and white pattern in the foreground is briefly indicated.

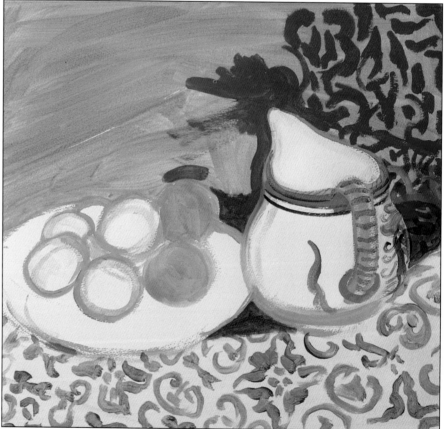

2 The most intense colours are in the plate of oranges and the jug which form the focal points of the composition, but as these have to be viewed as modified by the surrounding patterns, the colours of the cloths are strengthened at this stage to key the colour range. The artist then begins to paint the pattern on the jug.

3 At this stage the ceramic glaze pattern is treated as a line drawing with elements of local colour, much as it would have been drawn originally. The colours are monastial green tinted with white, burnt sienna, yellow ochre and ultramarine. The direction of the colour bands and angles of the floral motifs help to suggest the curving surface of the jug.

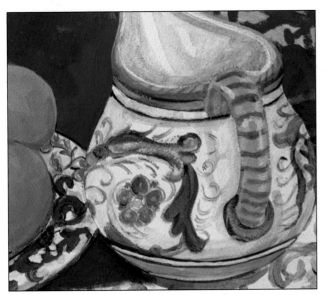

4 The jug pattern is easily refined and corrected by painting around the motifs with white. The shading on the inner and outer surfaces of the jug is then applied with a thin glaze of burnt sienna mixed with ultramarine. The dark tone is washed loosely over the colours and blotted with a paper towel.

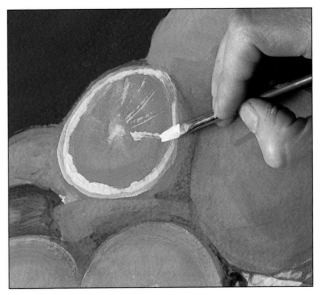

5 The strong blue of the background fabric is blocked in before the oranges are more fully painted. The basic shapes of the oranges are then modelled with mixes of cadmium orange, red and yellow, and the interior segments are thickly brush-drawn with a pale, creamy tint.

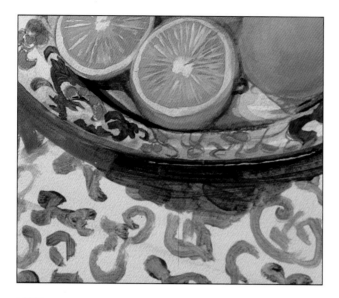

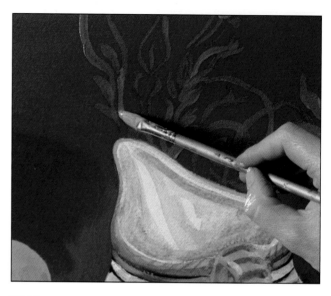

6 The detail of the plate pattern is treated similarly to that on the jug, drawing the surface pattern with the brush, then glazing shadows over it. A patch of dark-toned blue has been brushed in to correct shape of the plate rim, which also acts as a cast shadow underneath that creates more depth in the picture.

7 The original background colour now appears quite crude in relation to the more finished detail. The whole area is repainted with cerulean blue tinged with white and burnt sienna. Then the artist begins brush-drawing the beige pattern, using a subtle mixture of cadmium orange, burnt sienna, ultramarine, permanent mauve and white.

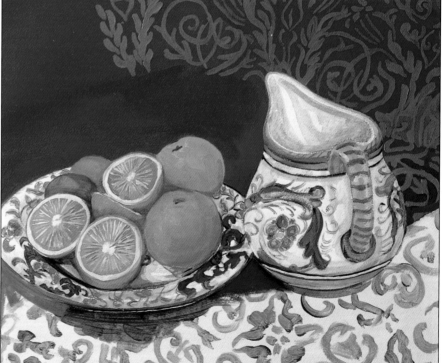

8 It is difficult to follow a complex pattern like this precisely, but it does not have to be wholly accurate, as long as the impression seems right. However, as the pattern spreads, the background looks flatly coloured. Some tonal variation has to be introduced to convey the planes and folds of the fabric and its slightly shiny surface texture.

9 The texture of the background fabric is now conveyed by painting darker and lighter shades of blue around the beige patterning, then touching the beige lines with occasional highlights, of the same basic colour mixture with more white added. Finally, the blue and white pattern in the foreground is repainted more strongly; the blue is ultramarine neutralized with burnt sienna, and the white is a creamy mix of titanium white and yellow ochre. Shading and cast shadow are glazed in over the colours with diluted dark blue.

Rendering
in pastel

For a subject like this with some very subtle colour changes, pastel is in some ways a more difficult medium to use, because the artist cannot pre-mix the colours and must match them approximately from her pastel range. In Hazel Harrison's rendering the bright colours of jug and fruits work well, and the blue and white fabric is gently shaded by letting the buff paper ground show through. In the background, the beige pattern has a more orangey tone than the original, but it is in keeping with the overall scheme.

INDEX

Page numbers in *italic* refer to the illustrations.

CREDITS

The author and publisher would like to thank all the artists who kindly submitted work for inclusion in this book. We would also like to thank the following organizations for their help and assistance:

The Pier
200 Tottenham Court Road
London W1

John and Sheila Elliot
Elliot Studios Galleries Ltd
304 Highmount Terrace
Upper Nyack-on-Hudson
New York 10960

Pages 16/17 reproduced with the kind permission of Winsor and Newton

Philip Dunn "Bank Holiday Monday"
© The Window Gallery
3 Dukes Lane, Brighton BN1 1BG
(0273) 726190